PISSARRO

PISSARRO

Christopher Lloyd

with notes by Amanda Renshaw

Phaidon Press Limited
140 Kensington Church Street, London W8 4BN

First published 1979
This edition, revised and enlarged, first published 1992
Second impression 1993
© Phaidon Press Limited 1992

A CIP catalogue record of this book is available from the
British Library.

ISBN 0 7148 2729 0

Printed in Hong Kong.

Cover illustrations:
(front) *Self-Portrait*. 1903. (Plate 48)
(back) *Crystal Palace*. 1871. (Figure 4)

Pissarro

'No, like Sisley, I remain in the rear of Impressionism', was how Camille Pissarro assessed his achievement as an artist in a letter to his son Lucien, written in February 1895. The statement is wholly characteristic of the man: slightly self-deprecating, ruthlessly self-critical, yet defiant and challenging. It is, however, more than an expression of self-doubt, for it also prompts a revaluation of Pissarro's role within the Impressionist movement. In this Pissarro is a pivotal figure. He was the only painter to exhibit his work in all eight of the Impressionist exhibitions held between 1874 and 1886, and in his letters many of the theoretical aspects and practical implications of the movement are clearly enunciated.

In many other ways, however, Pissarro is not the archetypal figure of Impressionism in the popular interpretation of that movement. He was born outside France, of Jewish descent. He displayed an interest in artistic movements that eventually transcended the tenets of Impressionism. He passed a great deal of his time out of Paris in the surrounding districts, and his works are governed by a political commitment that ran more strongly in him than in any of the other Impressionist painters. Such features give Pissarro's work a slightly different complexion from that of his associates, and indeed he assumed an almost rabbinical role in French art in the second half of the nineteenth century. Younger contemporaries spoke of Pissarro in biblical terms, as 'the Good Lord' and 'Moses', descriptions which seem especially appropriate in view of his physical appearance, marked by a long flowing beard which gives the face an authority only belied by the twinkling eyes peering over the top of the spectacles (Plate 48).

Allied to Pissarro's striking outward appearance was his wholly independent outlook on life. He was an assiduous worker for whom art was a quotidian exercise in the disciplining of the mind and the hand. His character is marked by a quiet resignation that can at times almost be equated with a streak of fatalism. Added to this was his loyalty to his family and friends. Above all, however, there was his single-minded approach to art, which won many adherents and made him an important centrifugal force within Impressionism, a movement which is a great deal more diffuse in its ideas, aims, and personalities than has often been imagined. Fortunately, throughout his life Pissarro evinced a remarkable gift for managing to remain on friendly terms with several particularly difficult personalities, including Degas, Cézanne, and Gauguin. Furthermore, he retained the respect of each of these artists and was frequently consulted by members of the younger generation, including Matisse, who was keen to talk about Impressionism with him. Yet, even though Gauguin, who had an amateur interest in graphology, detected all these characteristics when he analysed a sample of Pissarro's handwriting, he did finally conclude that, regardless of an outward calm, Pissarro harboured a nature that could only be

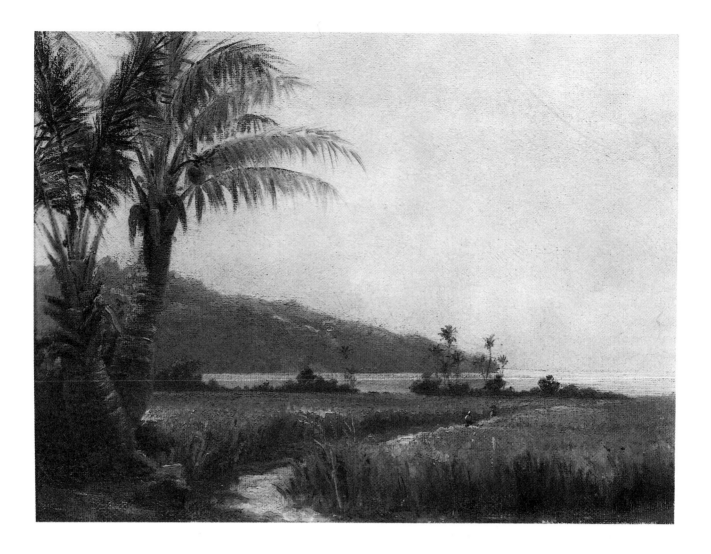

described as 'very complex'. It would be as well to keep this in mind when examining his paintings.

Jacob Camille Pissarro was born on the island of St Thomas in the Antilles in 1830. His father was a shopkeeper in Charlotte Amalie, the capital and principal harbour of St Thomas. The island was at that time a Danish colony, but the Pissarro family remained strongly Francophile. Apart from a short interlude in France at a school near Paris, which he attended between 1842 and 1847, Pissarro spent most of his early life on St Thomas, not abandoning the Antilles until 1855 (Fig. 1). This isolation from Europe is a fact of great importance for our understanding of Pissarro's development, for he was never exposed to a long period of formal training as an artist. A chance meeting in 1851/2 with Fritz Melbye, a Danish artist in the employ of the government, at least made Pissarro aware, albeit at one remove, of the strictures of academic art. Melbye's lessons were quickly absorbed during a short visit to Caracas, where they shared a studio. This formulative phase induced in Pissarro an acuity of eye, a spontaneity of expression, and an ingenuousness of spirit that was an auspicious start for someone who was later to become entangled with Impressionism. Above all, it encouraged Pissarro to be self-disciplined, and this was a quality that he never lost and that led to a perpetual desire to revise his style of painting. Significantly, on St Thomas and in Venezuela Pissarro interested himself in genre subject-matter and landscape, the very themes that recur later in his paintings in the context of rural France and become a central aspect of his art. There are, unfortunately, very few surviving paintings from this early period and those that do survive

are not particularly distinguished. The true quality of Pissarro's rapid development can, in fact, only be seen in his drawings, which are numerous and display a remarkable facility and boldness of execution.

Although Pissarro was undoubtedly exposed to contemporary European art while in the Antilles, it was only indirectly, in the form of prints, popular illustrations and manuals. When he arrived in Paris in 1855, in time for the Universal Exhibition, Pissarro had, for the first time since he was boy at school, direct access to the works of a host of famous artists. This, therefore, was an important moment in his life, for, like Cézanne, he developed a deep respect for the art of the past. Both artists were innovatory, but, like their Impressionist associates, the changes they introduced into painting were an extension of established principles rather than a complete revision of them. It was a question of knowing which painters to look at, or in which century to search, so that while Manet sought inspiration in Spanish painting, Renoir refreshed himself in the clear light of Italy, and Monet went to North Africa, Pissarro preferred Dutch and French art, mainly of the seventeenth and eighteenth centuries. The birth of Impressionism should perhaps not be regarded as *tabula rasa*, and its iconoclasm stems from its discontent with the sterile, outmoded and comparitively limited aims of academic art, rather than from stronger motives. 'Novelty lies not in the subject, but in the manner of expressing it', Pissarro wrote in 1884, and this statement implies that much of the apparent spontaneity of Impressionist painting was, in fact, carefully calculated.

At the Universal Exhibition the works of Delacroix and Ingres (Fig. 2) – the apparent polarities of French nineteenth-century painting – were strongly represented, among other schools, but it was to Corot that Pissarro initially felt drawn, and to the painters associated with the village of Barbizon in the Forest of Fontainebleau. It was, of course, with these painters – Troyon, Diaz, Rousseau, Millet, as well as Corot – that Pissarro felt a close kinship after his experiences in Venezuela, and it was with Corot that he formed his first definite artistic allegiance in France. The early work, *The Banks of the Marne* (Plate 1), which was exhibited in the Salon of 1864, displays a suppleness of brushwork, a candour in the treatment of light and a richness of tonality that reveal the direct influence of Corot. To Corot's example, however, Pissarro soon added others, specifically those of Daubigny and Courbet. Where in the paintings that technically owe a great deal to Corot the compositions are tight-knit and strong, those like *The Banks of the Marne at Chennevières* (Plate 3), which was exhibited in the Salon of 1865, have a spaciousness that is found in the work of Daubigny. Other paintings of this early period, such as *A Square at La Roche-Guyon* (Plate 4) or *Still Life* (Plate 5), which display broader brushwork with layers of thickly applied paint, are derived from the example of Courbet, whose uncompromising style of painting with the palette knife became a basic ingredient of Pissarro's own style. These three principal influences are perfectly blended in the small painting entitled *The Donkey Ride at La Roche-Guyon* (Plate 2), where the subject and the composition reveal Pissarro's sympathy with Daubigny and Courbet, but the execution his debt to Corot.

Such then were the principal formative influences on Pissarro after his arrival in France when, along with several other painters who were to form the Impressionist group, he sought recognition in the official Salons of the 1860s. From this amalgam Pissarro forged a personal style of painting, which in its first flowering was notable for its strength and individuality of touch, somewhat redolent of Manet in is *bravura* and not dissimilar to Monet's work in its richness. This early style is seen at its best in such paintings as *View of l'Hermitage at Pontoise* (Plate 6),

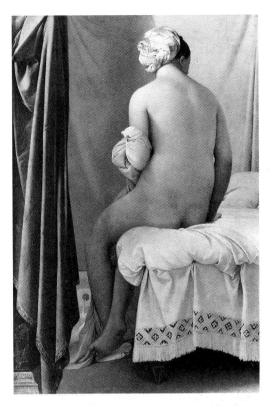

Fig. 2
Jean-Auguste Ingres:
Bather
1808. Musée du Louvre,
Paris

7

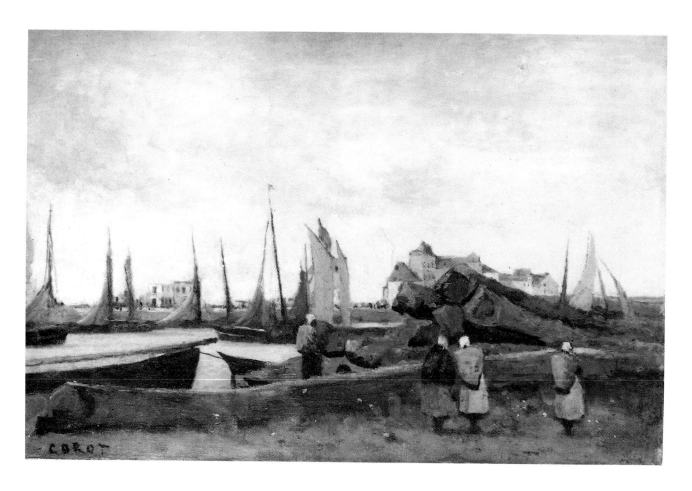

Fig. 3
Jean Baptiste Camille
Corot:
Quay at Le Treport
c.1855-65. Oil on panel,
27 x 40.6 cm.
Private collection

where the paint has been brushed on to the canvas in broad patches of sombre colour in such a way that when certain parts of the composition are viewed in isolation they resemble passages of abstract painting. This deliberate, almost rugged, method of painting was singled out for praise by the few critics, notably Emile Zola, who observed those works exhibited by Pissarro at the Salons, and it was this highly disciplined approach to composition that served as the basis for the important canvases completed during the first half of the following decade. Zola, in fact, wrote a strong defence of Pissarro's two pictures exhibited in the Salon of 1868, *L'Hermitage* and *Jallais Hill, Pontoise* (the latter now in the Metropolitan Museum of Art, New York), which ably summarizes the effect of these early masterpieces. 'The originality is here profoundly human. It is not derived from a certain facility of hand or from a falsification of nature. It stems from the temperament of the painter himself and comprises a feeling for truth resulting from an inner conviction. Never before have paintings appeared to me to possess such an overwhelming dignity. One can almost hear the deep voices of the earth and sense the trees burgeoning. The boldness of the horizons, the disdain of any show, the complete lack of cheap tricks, imbue the whole with an indescribable feeling of epic grandeur. Such reality is more than a daydream. The canvases are all small, yet it is as though one is confronted by a spacious countryside.' Zola concludes, 'Camille Pissarro is one of the three or four true painters of his day. He has solidity and a breadth of touch, he paints freely, following tradition like the old masters. I have rarely encountered a technique that is so sure.'

The decade of 1870-80 began in ferment with the Franco-Prussian war followed by the Commune in Paris. During both of these times of violence Pissarro was in England, together with Monet, Daubigny and Bonvin. Although each of these painters exerted some influence over Pissarro, it was principally Monet who gave direction to his work at this

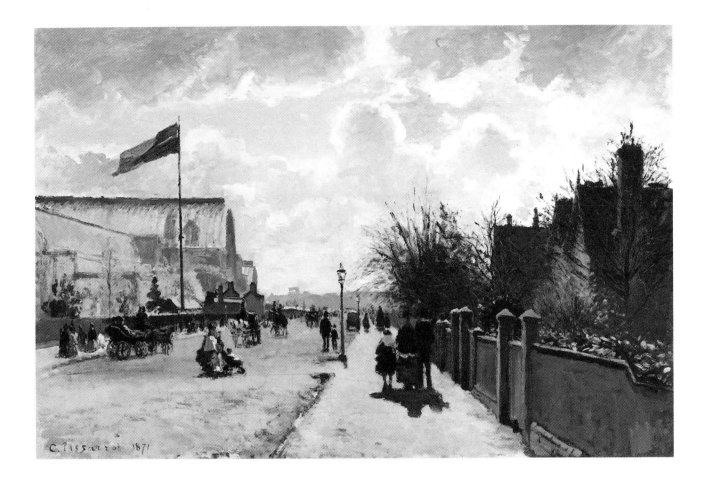

stage. It is wholly characteristic of Pissarro that while Monet painted in the London parks, he chose to remain in the suburbs. Yet in the canvases painted in England and shortly after his return to France there is, as in Monet's work of this period, a lighter, more spontaneous touch and a brigher palette, the colours applied in smaller patches so that the surfaces appear to be crisper and more active. Together with this more vibrant brushwork is the firm geometric structure underlying the compositions that had already been used for the pictures painted at the end of the previous decade. The paintings are governed by lines of vision that lead perpendicularly into the compositions (Fig. 4). These are often countered by low horizon lines. The figures and buildings are placed on diagonals drawn at varying angles. These canvases, however, are more than mere exercises in geometry, for, although the compositions can be fairly rigid, Pissarro also involves the viewer in the visual interaction between the various parts, as in the foreground of *The Crossroads, Pontoise* (Plate 9). In such pictures (see also Plates 12, 13 and 14) the artist also explores the full range of dramatic possiblities implicit in roads disappearing over low horizons and paths that follow the contours of the hills. To examine these paintings, several of which are small in size, is to discover that they have the same succinctness of expression combined with the same breadth of interpretation that governs an all-embracing mathematical or philosophical proposition. Furthermore, when individual passages are seen separately as details they do themselves form independent compositions. Many of these canvases of the early part of the 1870s, which include flower-pieces (Plate 10) and family portraits (Plate 11), are among the most satisfying that Pissarro painted and they are also in his purest Impressionist manner.

In the middle of the decade Pissarro renewed his acquaintance with Cézanne (Plate 16), whom he had first met in Paris, reputedly at the

Fig. 4
Crystal Palace
1871. Canvas,
48 x 73.5 cm.
Mr. and Mrs. Bensinger,
Chicago

9

Académie Suisse, not long after his arrival from St Thomas. Pissarro now established a rapport with Cézanne that was to be of the utmost significance for the development of European painting. The two artists frequently worked together, often painting the same subject, and it is likely that any influence they exerted on one another was on a reciprocal basis (Fig. 5). Regardless of their different personalities, their letters reveal a similar commitment to art and a similar purpose in painting, just as drawings and photographs of them show that they dressed in a comparable manner for their forays into the countryside.

As a result of his relationship with Cézanne, which was at its closest between 1872 and 1877, Pissarro's own style of painting changed and became more aggressive. The palette again darkened and became more unified. The brushwork was broader and more forceful, the paint surface itself characterized by an immense solidity that has the appearance of being modelled (Plate 17). Apart from technical considerations, Pissarro and Cézanne also shared an architectonic approach to composition, and Cézanne's description in a letter of 1906 to his son, of some trees in a wooded landscape as forming 'a vault over the water', could easily be applied to a picture such as *The Little Bridge, Pontoise* (Plate 18), which was painted by Pissarro during this very period.

It may, in fact, have been as a result of working with Cézanne that Pissarro began to overload the surface of his pictures. In both *Kitchen Garden with Trees in Flower* (Plate 21) and *The Red Roofs* (Plate 20) the hillside and the buildings are screened by foliage. The effect of this is to draw the eye, as with a kaleidoscope, into the densely patterned background. The eye then attempts to separate the various layers, at the same time glorying in the visual opulence that it finds there. The myriad of short, varied brushstrokes purvey an increasingly wide range of colours, and perhaps only Monet amongst the Impressionists was equal to this detailed and elaborate method of working.

Pissarro, however, was aware of the difficulties of painting in this way. He complained frequently of the fact that his paintings lacked visual clarity and were often dull or muddy in colouring. He became acutely conscious, in fact, that he was over-painting. The density of the surface of these pictures executed at the end of the 1870s and at the beginning of the 1880s was overpowering, and the moment when the form itself suddenly emerged out of the background was harder to achieve. One only has to look at the still-life objects on the table on the right of the composition of *The Little Country Maid* (Plate 27) to see how they have become isolated from the rest of the picture. The laboured treatment of the teacup is an instance of this over-elaboration. It appears to be almost floating on the table-cloth, unconsciously resembling one of Monet's waterliles (Fig. 6). In seeking a solution to this, Pissarro found the theories propounded by Seurat and Signac, involving the division of colour on a scientific basis, to be sympathetic. Like his contemporaries Renoir and Monet, who suffered similar difficulties in their style of painting at this time, Pissarro looked outwards for fresh inspiration. It is also significant that the brushwork used for those paintings executed during the late 1870s and early 1880s, with its neat, short, nervous flicks and commas, anticipated the more regular brushstrokes advocated by the Neo-Impressionists. In addition, the purity of the colour and the brighter palette enabled Pissarro to rid himself of the muddy effects of his heavily worked canvases. His paintings in the Neo-Impressionist style (Plate 30 and 31), which he adopted between 1885 and 1890, were, therefore, possibly a palliative for the difficulties that he had been experiencing since the late 1870s.

Having recaptured purity of colour and clarity of composition, however, Pissarro found the Neo-Impressionist style increasingly

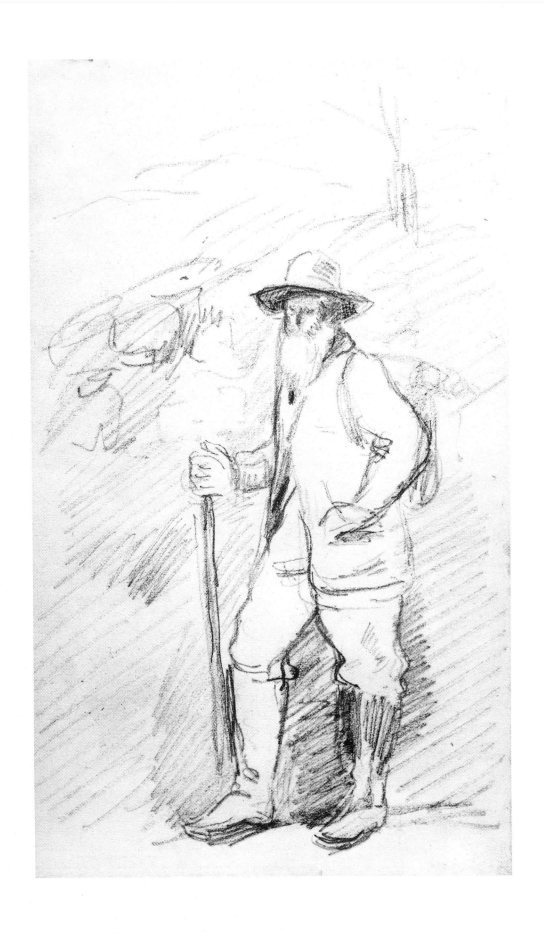

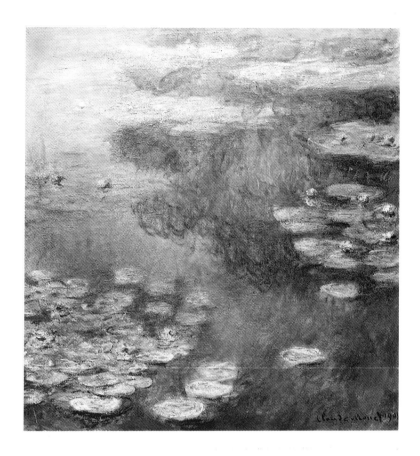

frustrating. The canvases had to be worked on in the studio over long periods. The dot was a painstaking method with which to cover the whole surface of a picture, and it did not allow the artist to record freely those sensations which he had experienced before nature. Pissarro came to resent the technical limitations imposed upon him by Neo-Impressionism, but nevertheless remained a stalwart admirer of Seurat and was deeply affected by that early artist's death in 1891.

Already in the examples of Cézanne and Seurat we have seen how Pissarro developed his own style of painting by openly embracing a method or technique that was at first sight unrelated to his customary manner of working. Another relationship that is reflected in his art began towards the end of the 1870s and persisted into the 1880s. This was his friendship with Paul Gauguin, to whom his attitude was distinctly equivocal. He seems at first to have admired the break that Gauguin made from the trammels of his family, but later to have despaired of his arrogance and of his persistent use of symbolism. None the less, at the outset, during the late 1870s, Pissarro and Gauguin painted together in areas around Pontoise when Pissarro was himself reconsidering his own style of painting. It was, however, not merely a question of style, and there can be little doubt that for Pissarro the early 1880s were a period of deep inner reflection. Firstly, he discovered several new subjects as a result of travelling more widely. His first protracted visit to Rouen in 1883, for instance, brought him into contact with a city that had a strong topographical tradition among French and English artists. In paintings, drawings and prints Pissarro began to capture the appearance of the city – its streets, its majestical cathedral, its busy port – and he was to return to it on several occasions during the 1890s. Apart from the topographical emphasis that the paintings of Rouen demanded, there was also a whole range of atmospheric effects that he determined to translate into paint. As he wrote in a letter of 1896 while painting one of his series of views of the city, 'I have effects

of fog and mist, of rain, of the setting sun and of grey weather, motifs of bridges seen from every angle, quays with boats; but what interests me especially is a motif of the iron bridge in the wet, with much traffic, carriages, pedestrians, workers on the quays, boats, mist in the distance, the whole scene fraught with animation and life', (Plate 36).

There is, therefore, a considerable broadening in the range of subject-matter treated by Pissarro, which is best exemplified by the number of market scenes executed during the 1880s (Plates 28, 29 and Fig. 30). He had begun to observe markets while in South America, but it was not until he was living in Pontoise and Gisors that he pursued the theme with ardour, depicting the various markets – poultry, grain, egg, vegetable – in densely populated compositions that were to be his equivalent of the urban subjects of Manet, Degas and Renoir. In these market scenes there is a wide spectrum of physical types – both peasant and bourgeois. Even in South America Pissarro's pithy style of drawing had encouraged a caricatural element in his work, and throughout his life he admired artists such as Constantin Guys, Honoré Daumier, and above all Charles Keene. Drawings from this period show Pissarro establishing a basic repertoire of figures, all drawn so quickly that only their principal features or characteristics are recorded, in a summary fashion, on the page. Such strongly delineated sketches appear to be caricatural even if humorous anecdote was not the intention, and the

Fig. 7
Old Convent of Les Mathurins, Pontoise
1873. Canvas,
59.7 x 73.3 cm.
Private collection

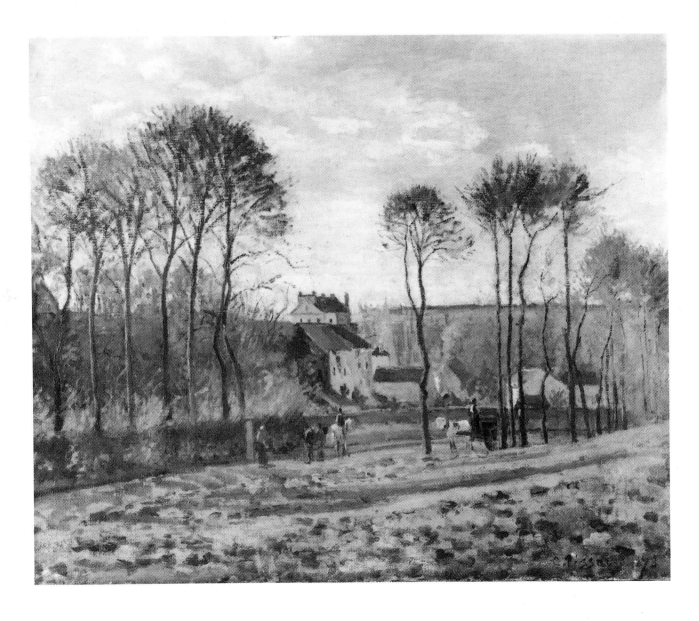

Fig. 8
Autumn Landscape,
near Louveciennes
c.1871-2. Canvas,
45.8 x 56 cm.

exploitation of humanity's foibles extends beyond the market scenes to include his boulevard pictures (Plate 23), where the figures are admittedly represented from a distance, but are granted individually with the aid of a caricatural style. Secondly, during the 1880s and early 1890s Pissarro began to reinterpret themes that he had already explored. This development was due to two factors: a new understanding of the human figure and a fresh response to nature. Out of this emerged a new type of composition in which the principal novelty was the relationship of the figure to the landscape. During the 1870s Pissarro tended to place his figures in a subordinate role in relation to the landscape. The figures are seen working in the fields or walking along the roads, but usually in the middle or far distance, and often forming part of a broad panorama which dominates the picture and contains the figures (Figs. 7-13). They are directly related to the landscape, but only so far as they are perfectly integrated with their surroundings. The figures are often columnar, and even when they do come into contact with the ground, as in the acts of weeding or picking, they tend to bend stiffly from the waist, as though manipulated from above like puppets. Towards the end of the 1870s, however, Pissarro evolved a more sympathetic treatment of the human figure in which his models are not generalized, but closely observed, their dress, and particularly their actions, dextrously recorded. While *Landscape at Chaponval* (Plate 24), for instance, still tends to show the figure isolated and upright, set

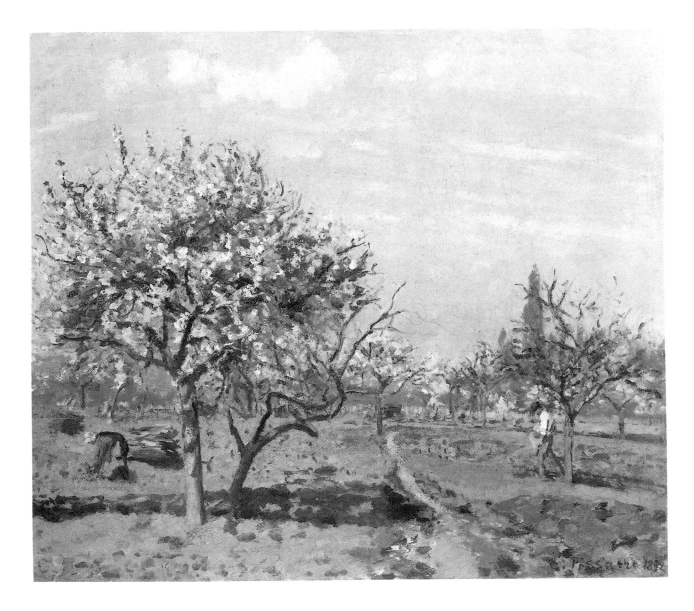

against the contour of the hillside, *Two Female Peasants Chatting* of 1892 (Plate 32) epitomizes the change of emphasis that Pissarro brought to his treatment of the human figure during the 1880s. Although the lower halves of their bodies are cut, the two young women are far more earthbound than their predecessors of the 1870s. They are defined as individuals by their dress and by their features, and their physical activity, from which they are relaxing, is suggested by the implements they hold and by the background. In paying such close attention to descriptive detail, Pissarro has not failed to relate the figures to the landscape. This integration is exactly the same as that so admirably demonstrated by the paintings dating from the 1870s, but is achieved in a totally different way. Here the figures are united with the earth. Where before they stood, or bent down to have some contact with the ground, now they sit, recline, crouch, or squat, so that the figure and the earth seem no longer separate entities, but perfectly fused (Fig. 14). This develpment in Pissarro's style is fundamental to our understanding of him as an artist. It implies a more profound appreciation of peasant activities and it was achieved by a closer observation of the peasant at work, or at rest, in the fields surrounding the towns and villages to the north of Paris where Pissarro lived.

This more sympathetic treatment of the human figure in Pissarro's paintings was effected contemporaneously with a change in his rendering of landscape. It has been seen that during the 1870s Pissarro

Fig. 9
Orchard in Bloom,
Louveciennes
1872. Canvas, 45 x 55 cm.
National Gallery of Art
(Ailsa Mellon Bruce
Collection), Washington
DC

15

Fig. 10
Spring
1872. Canvas, 55 x 130 cm.
Private collection

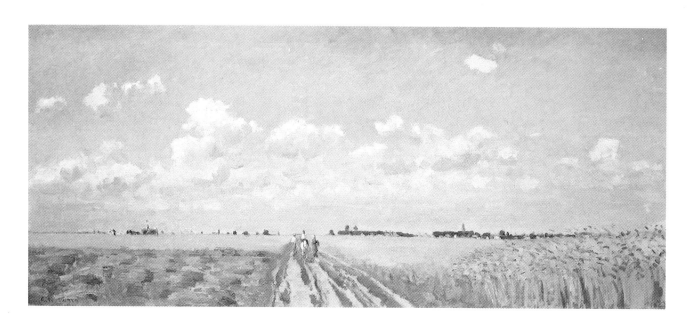

Fig. 11
Summer
1872. Canvas, 55 x 130 cm.
Private collection

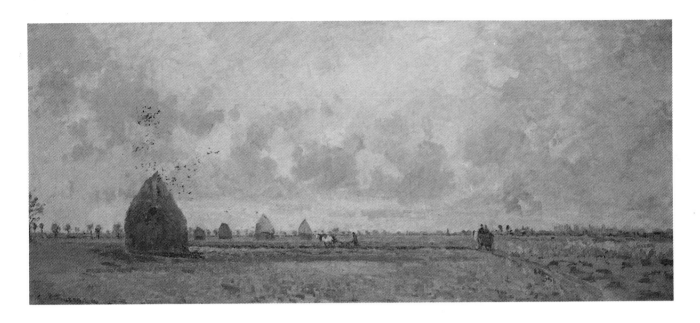

Fig. 12
Autumn
1872. Canvas, 55 x 130 cm.
Private collection

Fig. 13
Winter
1872. Canvas, 55 x 130 cm.
Private collection

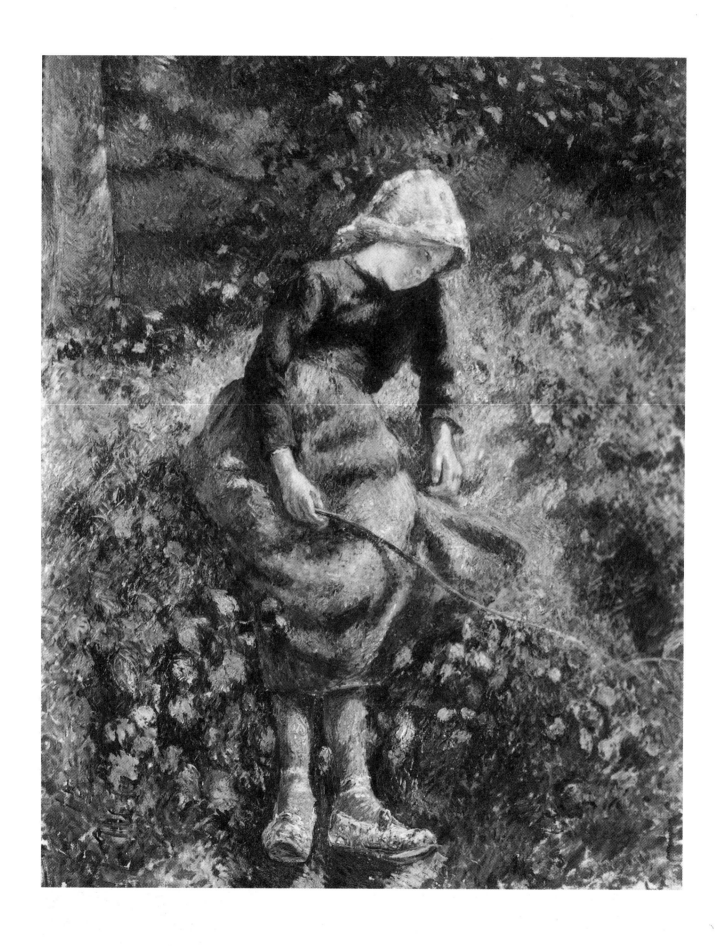

concentrated upon integrating the human figure into the background. During the 1880s and the early 1890s, possibly owing to the growing influence of Degas, there was an icreasing tendency to place the figures, whether set in a landscape (Plate 32) or in an interior (Plate 26), in the immediate foreground, posed at angles to the picture plane, often silhouetted against the background and even occasionally deliberately distorted. They are brought into closer contact with the spectator as they loom out of the canvases, and to a certain extent negate the landscape or interior in which they are painted. The function of landscape therefore changes. Where during the 1870s the possiblities of the firm geometrical structure allowed a great deal of flexibility as the levels of the horizons, the diagonals and the perpendiculars were changed, during the later decades this variety was narrowed down to one or two formulas which were repeated in several different types of composition.

The principal difference between the landscape compositions of the 1870s and those of the 1880s, therefore, lies in the treatment of space. Those painted in the 1870s have a predilection for spatial recession: roads, rivers, lines of trees disappear into the distance. In the paintings dating from the 1880s the compositions are more enclosed and the horizon lines are often placed above the heads of the figures, so that there is an upward progression of flat horizontal bands. Again the transitional stage is marked by a painting such as *Landscape at Chaponval* of 1880 (Plate 24), where the figure is placed in the foreground and outlined against the field. She is still carefully integrated into the landscape, but there is a tendency to flatten the various parts of the composition. Another transitional painting is *The Harvest* of 1882 (Plate 25), in which the half-length figures in the foreground are set within a landscape bounded by a low horizon line with a shallow hill that is actually painted more than half-way up the canvas. A fine example of the new landscape formula when it was fully developed is provided by *The Apple Pickers* of 1888 (Plate 31), which is painted in the Neo-Impressionist manner. The curved horizon line, the tree placed just to the right of centre, the figures perched rather uncertainly on the ground, which appears almost to tip forward towards the viewer – these are its salient features. Familiarity with a particular landscape, such as the orchard of his house at Eragny or the nearby meadows of Bazincourt, encouraged the ready adoption of such formulas. The variety in the paintings stems solely from the figures, their varied activities and their poses, while the landscapes merely provide a suitable stage or backcloth.

Once more in this respect Pissarro's espousal of Neo-Impressionism was an advantage, for it provided him with the means of achieving visual clarity on a densely worked surface. The effect of tipping up the landscape, so that the feeling of recession was negated and the figures were pressed against the background like flowers between the pages of a book, could easily have resulted in a loss of definition. The fact that the figures stand out so sharply from the backgrounds is due to the refinement of technique and colour that Pissarro had attained through the practice of *pointillisme*. In addition, he never totally abandons his sure sense of spatial division, for the geometry of diagonals, horizontals and verticals continues to grant the various parts of the composition an undeniable sense of unity (Plate 31). The brushstrokes retain the short, comma-like form they possessed before 1885, but the adoption of lighter colours in a purer state enables Pissarro to create, by a process of subtle modulation, a sense of distance, and to recapture the palpable atmospheric effects that had been evoked with broader strokes in earlier pictures. The paintings of the last half of the 1880s, therefore,

Fig. 14
Peasant Girl with
a Stick
1881. Canvas, 81 x 65 cm.
Musée d'Orsay, Paris

Fig. 15
Georges Seurat:
Young Woman at her
Toilette
1889-90. Canvas,
94.5 x 79.2 cm.
Courtauld Institute
Galleries, London

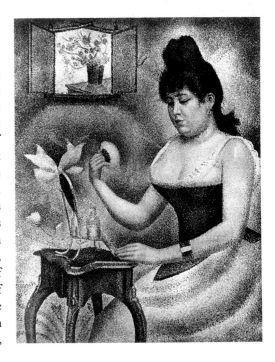

Fig. 16
White Frost, Woman
breaking Wood
1889-90. Canvas,
126.4 x 128.3 cm.

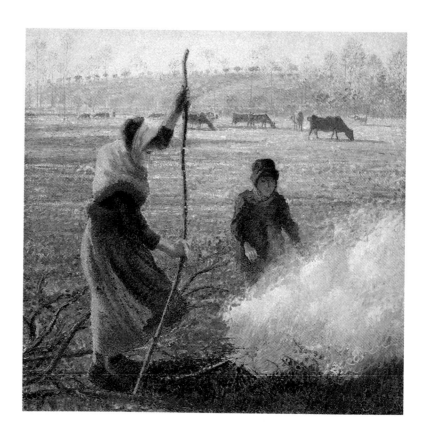

may not be so easy to appreciate as those of the 1870s, but they are products of a remarkably successful combination of Pissarro's innate skill in organizing space and his newly developed ability in rendering atmosphere with colour.

There is also a marked difference in the treatment of light between the paintings of the 1870s and those of the 1880s and the 1890s (Fig. 16). This, too, must have helped Pissarro to achieve a visual unity in his compositions. The picture *Two Female Peasants Chatting* (Plate 32), for example, is bathed in an intense, clear light. It has a luminosity that is not shared by the earlier paintings, in which the sharp light striking buildings, trees and figures is used merely to prescribe their forms. In such works light is used descriptively, whereas in *The Apple Pickers* (Plate 31), or in *Two Female Peasants Chatting*, the intensity of light envelops both the figures and the landscape. This luminosity exists as if to allow us to see the figures properly in their setting.

The paintings of the mid and late 1890s are, on the other hand, similar in many respects to those of the 1870s, although the technique is a natural development from the Neo-Impressionist phase. Many of the canvases are heavily worked, but the visual content is immediately comprehensible and solidly constructed in the manner of the 1870s. The compositions of interiors are still contrived, partly as a result of using posed models (Plates 34 and 35). In the landscapes the paint is thickly applied and layered onto the canvas so that it almost embosses the surface with supple, full-bodied brushstrokes (Plate 43). These paintings mark the return from *pointillisme* and are almost a celebration of Pissarro's rediscovery of the textural qualities of paint. The motifs of the fields surrounding Eragny and the peasants who work in them become far less frequent. Even the beloved orchard at Eragny occurs only occasionally (Plates 42 and 43). Instead, Pissarro explored subjects that he had never painted before with such persistence. He was partly driven to this by necessity after contracting an eye disease diagnosed as an infection of the tear duct, which caused him to remain indoors. As a result he painted views that he could observe from behind the protec-

tion of a window in a house or an hotel. An increasing interest in urban themes is demonstrated by the series of boulevards, bridges, harbours, buildings and gardens, painted predominantly in France (Paris, Rouen, Dieppe and Le Havre), but also in England, which Pissarro visited several times during the 1890s to see his son Lucien. Significantly, Pissarro remains above street level (Plates 34-41). He does not go down into the streets; the people who pass along them do not really interest him, and they are briefly drawn onto the canvas without being closely defined. These paintings have an urban claustrophobia, which is an important clue to our understanding of Pissarro, whose deliberate evocation of the countryside has to be balanced with this late return to a traditional subject of Impressionist painting.

As in the 1870s, Pissarro now explored temporal effects. His urban views show the gardens (Plate 39), the boulevards (Plate 37) and the buildings (Plates 46 and 47) of French cities in the morning light, in the rain, in the mist, and each at a different time of day or year. Beyond this habit of relentless work there is a rekindling of the desire to paint in series, so that Pissarro's career, like Monet's, ends almost symphonically; both artists bring all their experience to bear on the depiction of those effects that are the quintessence of Impressionism – time and light. These canvases demand the viewer's close attention. Their subtlety lies not just in the colour, which is less intense now and rather suffused with a silvery tone, but also in the dexterity of the physical application of paint, no doubt the result of a protracted working process as the artist's powers of concentration failed. On short acquaintance these paintings might appear to be too uniform, but, like Monet's more renowned series of haystacks and water-lilies, the late paintings of Pissarro draw you into a closed world of miraculous colour contrasts and multifarious brushstrokes.

These urban themes, however, were not the only subjects that Pissarro essayed during the 1890s. A new departure is marked by the painting *Young Woman Bathing her Feet* (Plate 33). Scenes of such intimacy are rare in Pissarro's work, but in several paintings executed during this final decade, and even more in his prints, the artist suddenly undertakes a study of female bathers in sylvan settings, somewhat in the manner of Cézanne and Renoir. Pissarro frequently complained that he was inhibited by the lack of female models, but this did not prevent him from attempting several Arcadian compositions which may be directly compared with an earlier French tradition, namely that of Boucher and Fragonard.

This is not the least surprising aspect of the final decade. Particularly moving is the realization that Pissarro's fascination with the ports of Dieppe and Le Havre echoes the scenes first witnessed as a youth at Charlotte Amalie, the capital of the island of St Thomas. Thus, Pissarro's life seems to have progressed in a cyclical way, creating a surprising unity out of a vast oeuvre of paintings, drawings and prints. By the 1890s these two French ports were also fashionable seaside resorts, but Pissarro eschewed the attractions of the social life pursued there and, as at Rouen, he preferred to observe the activities of quaysides and harbours. People, as elsewhere in these late works, are of no great consequence, but instead the rain, the wind, the smoke, and the movements of the various types of shipping hold him in thrall (Plates 44 and 45). When it is recalled that in the nineteenth century the approach of death is often symbolized by marine imagery, Pissarro's preoccupation with the shipping at Dieppe and Le Havre cannot be misconstrued.

This short examination of the style of Pissarro's paintings has revealed that fundamentally he retained the same principles throughout his working life. Underlying all his compositions is a predeter-

mined framework. The figures and the backgrounds bear a closely defined relationship one to the other, and the precision with which their positions are plotted on the canvas, even where there is an attempt to conceal this from the viewer, demonstrates with what care Pissarro planned every composition. The essential differences in the treatment of space noted between the canvases of the 1870s and those of the 1880s really amount to different solutions to the same problem. In this matter it is hard to divorce Pissarro's personality from his artistic output, for his paintings do seem to be a perfect expression of his character as we know it from his own letters or from the writings and utterances of contemporaries. The very deliberate way in which Pissarro devised his compositions emphasizes his single-minded approach to life. Indeed, the artist's ability to translate nature as he saw it before him onto his canvas suggests more than the astonishing eye for shape and form that had impressed Cézanne, and indicate, as Zola realized at the outset, something more deep-seated than skill. One is therefore bound to ask whether Pissarro had a particular philosphy of life and what relationship, if any, it bore to Impressionism.

It is true to say that Pissarro, as he himself was fully aware, stood slightly apart from his contemporaries in the Impressionst movement. 'I have in me something which chills the enthusiasm of people – they become frightened', he wrote to his son in 1891. While no single painting by Pissarro can be described as overtly political, he was, nonetheless, a man with strong political convictions, and these are often reflected in the subject-matter of his paintings. The *Portrait of Cézanne*, which was painted in 1874 and was still kept in the painter's studio at the end of his life, provides us with some insight into these political views (Plate 16). The figure of Cézanne is seen in three-quarters profile, looking out of the picture to the right. He is dressed in outdoor clothes and wears a cap. Presiding over him, and therefore by implication over Pissarro, are two political cartoons from French newspapers. On the left, a cartoon by André Gill from *L'Eclipse* of 4 August 1872, entitled '*La Délivrance*', shows Adolphe Thiers holding a new-born baby which represents the indemnity paid to the Germans after the Franco-Prussian war, while France, personified by the woman reclining on the bed, looks on. In the upper right corner of the portrait there is a cartoon by Léonce Petit from *Le Hanneton* of 13 June 1867, which shows the painter Gustave Courbet, with a palette in his hand and a clay pipe in his mouth. These are the polarities of Pissarro's political world: on one side Thiers, the entrenched conservative, the crusher of the Commune, and on the other, Courbet, whose paintings and manifestos deliberately taunted the bourgeoisie. Pissarro had been born into a bourgeois family. He later described his visit to Venezuela in 1852-4 to the young painter Armand Guillaumin as follows: 'I was at St Thomas in 1852 in a well-paid job, but I could not stick it. Without more ado I cut the whole thing and bolted to Caracas in order to get clear of the bondage of bourgeois life.' This statement should not be taken as a true expression of Pissarro's political views at that early date, but it is certainly apparent that his opinions hardened after arriving in France in 1855, so that by 1882 Renoir was protesting, 'The public does not like anything that smacks of politics and I do not wish at my age to be revolutionary. To remain with Pissarro the Jew is to be tainted with revolution.' Pissarro expressed sympathy with the anarchist movement in France, but he was not an activist and is far removed from the traditional image of anarchists derived from the novels of Joseph Conrad or Fyodor Dostoevsky. In fact, as regards the main political events that took place in France during his lifetime, Pissarro is conspicuous by his absence, and the report prepared on him by the police shows that they

were not deeply concerned about his political sympathies. How then were these views expressed in Pissarro's paintings?

Pissarro is often compared with his illustrious predecessor Jean-François Millet, but there is in fact a clear distinction between their work, and an entirely different purpose in their treatment of peasant life. Pontoise, for instance, where Pissarro lived from 1866 to 1868 and 1872 to 1883, was to the north of Paris in an area that was rapidly changing its character. There factories were being built as a result of industrial expansion. Factory buildings were beginning to dominate the landscape, just as they were forcing changes on the character of the population. The pattern of rural life was becoming fragmented as those families who had previously worked on the land were being sucked into large conurbations. Pissarro's paintings of factories (Plate 15), which were executed during the mid 1870s, do therefore accurately record an economic development in French society, but it was not one with which the artist appears to have been wholly in sympathy. The fact that urban growth was having such a dramatic effect on nineteenth-century life in France meant that Pissarro's view of the peasant was very different from Millet's. Indeeed, this is reflected in the changing attitude to Millet's own paintings, which during Pissarro's lifetime had come to be equated with romantic evocations of the countryside overlaid with religious feelings. Millet's peasants fill the canvas with Michelangelesque proportions. They are bounded by strong contours; they have a fatalistic air; they are depicted as slaves in a base and corrupt world, seeking ennoblement in the court of humanity. Their plight, however, is changeless. It is a static world from which there is no means of escape. As Degas once remarked, Millet's paintings are for God, Pissarro's are for man.

Pissarro is not concerned to show the peasant way of life in such a pessimistic light. Indeed, he saw that very way of life as an important corrective to the suffering induced by the growth of urbanization so vividly depicted in his album of drawings entitled *Turpitudes Sociales* (1890; Fig. 17). For inherent within rural society was the only remaining acceptable form of social justice. Thus Pissarro hoped to re-establish the structure, rhythm and pattern of rural life, not in its outmoded, sentimental, medieval form, but in a modern context. The countryside for Pissarro was not simply a retreat from urban life, a place for refreshing the spirit, but the only viable alternative to the social ills poisoning life in the towns and cities. As such, the *mores* of peasant life provided an important blueprint for the future and were seen as the only means of obtaining salvation in this world. Such sentiments represent a shift from the world of martyrology to that of the pedagogue, and with Pissarro the theme of the peasant in art does indeed change from a myth into a confirmed political philosophy. One observes that Pissarro's paintings of peasants, executed during the 1880s when he first began to develop these ideas in full, are bathed in a clear, sharp light of almost visionary quality, which to a certain extent emphasizes the idealistic nature of his art (Plate 25). For Pissarro's attitude to the peasant is an admixture of the eighteenth-century Enlightenment and nineteenth-century Utopianism, reinforced by a reading of contemporary anarchist tracts published by such friends as Jean Grave, as well as by his own observations made in the outlying country districts where he chose to live. The thinkers who influenced him most were Proudhon, Kropotkin and Reclus, whose works he knew well and whose ideas fuelled his own passionate concern for humanitarian principles.

When Pissarro first exhibited his work in the official Salons, critics naturally concentrated their faculties on his style of painting, but later

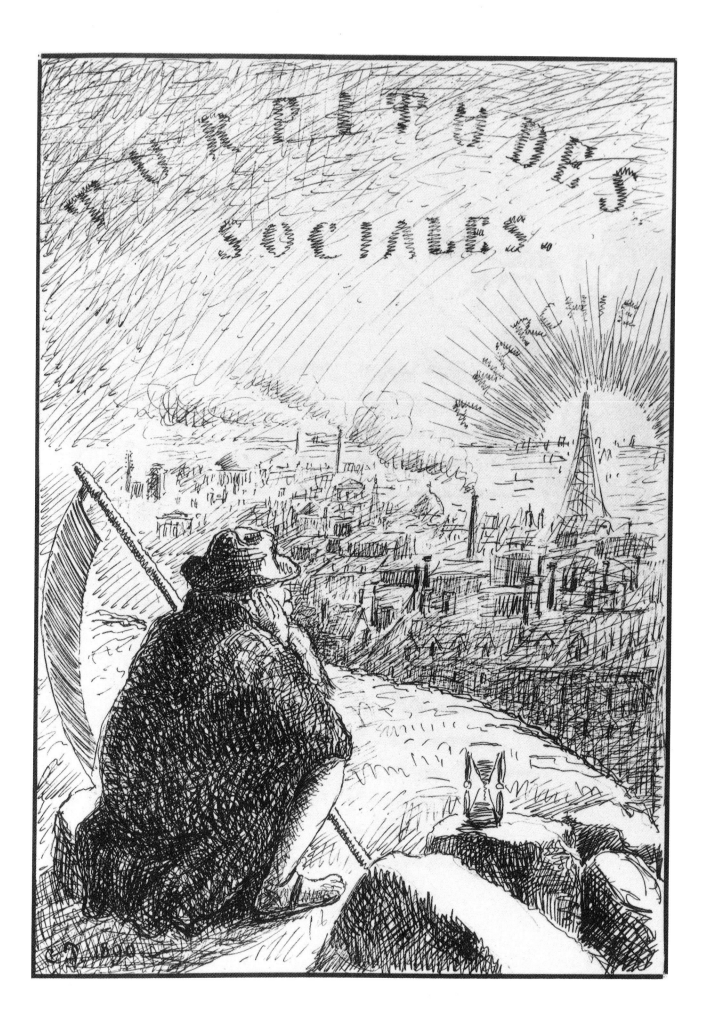

critics of a younger generation recognized, even more clearly than Zola, the relationship between the style of the artist and the philosophy of the man. Such writers were Félix Fénéon, Gustave Geffroy, Georges Lecomte and Octave Mirbeau, all of whom were friends of the artist. Geffroy wrote at the time of an exhibition of Pissarro's work held at the gallery of Durand-Ruel in 1894, 'The philosopher and the poet are inseparable within his work and the result is not only a practical demonstration, but also an illuminating résumé of the nature of things and of passing phenomena magnificently and definitely captured'. Mirbeau, in his moving preface to the catalogue of the posthumous exhibition of 1904, wrote, 'The eye of the artist, like the mind of a philosopher, reveals the larger aspects of things, the totalities, the harmony'. In recent times it has been the failure to realize this connection between the art and the thought of Camille Pissarro that has dogged the study of his work and, indeed, that of his fellow Impressionists as well. 'Remember', he wrote to his son in November 1883, 'that I have the temperament of a peasant [*rustique*], I am melancholy, harsh and savage in my works, it is only in the long run that I can expect to please, and then only those who have a grain of indulgence; but the eye of the passer-by is too hasty and sees only the surface. Whoever is in a hurry will not stop for me.' Pissarro's lack of success not only resulted in periods of financial hardship, but also caused him to question the validity of his own work and ideas. On such occasions he turned to his son for reassurance, and it was Lucien who replied to his father in 1894, 'You are surprised that the public does not look at your paintings and you explain this by supposing that they lack something essential. But do you not realize that it is only a question of fashion? You are too reserved [*tranquille*], you have ideas that are too expansive [*large*], and you are too sensible [*bon*] to be fashionable. Indeed, you have yet to be discovered.'

Fig. 17
Turpitudes Sociales
1890. Pen and brown ink on paper, 31.5 x 24.5 cm.
Mr. Daniel Skira, Switzerland

Outline Biography

1830 Born on 10 July, on the island of St Thomas, West Indies.

1842-7 School at Passy in France.

1847-52 Returns to St Thomas.

1852-4 Visit to Venezuela with Fritz Melbye.

1855 Returns briefly to St Thomas, and towards the end of the year leaves the West Indies for Paris.

1856-8 Paints and studies in Paris.

1859 A landscape accepted by the Salon jury; exhibits several pictures at the Salons of 1864, 1865, 1866, 1868, 1869 and 1870.

1860-5 Works in the countryside surrounding Paris.

1861 Meets Monet and Cézanne at the Académie Suisse.

1863 Participates in the Salon des Refusés. Birth of eldest son, Lucien.

1866 Settles in Pontoise.

1869 Moves to Louveciennes.

1870-1 Franco-Prussian War and the Commune in Paris; flees to Brittany and then to London, where he marries Julie Vellay, who was to bear him a further six children. Meets Durand-Ruel, the Parisian dealer who bought and exhibited the work of the Impressionists.

1871 Returns to Louveciennes.

1872 Settles again in Pontoise, and also paints in nearby Osny and Auvers-sur-Oise, often in the company of Cézanne and Guillaumin.

1874 Contributes to the First Impressionist Exhibition and subsequently to the other seven Impressionist group exhibitions, 1876, 1877, 1879, 1880, 1881, 1882 and 1886.

1874-7 Frequently works in Brittany at Foucault, near Mayenne, at a farm owned by an artist friend Ludovic Piette, who dies in 1877.

1878 Establishes a studio in the Rue des Trois-Frères, Paris.

1883 Lucien Pissarro leaves for England and his departure marks the beginning of an extended correspondence. Important visit to Rouen, where he returns several times during the 1890s.

1884 Moves, and finally settles in Eragny after a short period at Osny. In 1892 Madame Pissarro buys the house with its orchard which, together with the surrounding areas, has been the subject of several paintings since 1884. The artist's studio was situated in the orchard and is still standing.

1885 Meets Signac and is introduced to Seurat, with whom he discusses the technique of painting.

1885-91 Adopts the Neo-Impressionist manner for his paintings and exhibits with avant-garde groups in Brussels and Paris.

1890 Visits London to see his son Lucien; also in 1892 and 1897.

1894 Outbreaks of anarchist violence in Paris. Flees to Knokke-sur-Mer in Belgium.

1893-1903 Paints several series of urban themes based on the cities of Rouen, Paris, Dieppe and Le Havre, usually viewed from hotel rooms.

1903 Dies on 13 November in Paris.

Select Bibliography

MONOGRAPHS

Kathleen Adler, *Camille Pissarro: a Biography*,
London, 1978

Richard Brettell, *Pissarro and Pontoise:
the Painter in a Landscape*, New Haven, 1990

Ludovic Rodo Pissarro and Lionello Venturi,
*Pissarro son Art – son Oeuvre, Catalogue
Raisonné*, 2 volumes, San Francisco, 1989

John Rewald (ed.), *Camille Pissarro. Letters to his
son Lucien*, New York, 1972

R. Shikes and P. Harper, *Camille Pissarro.
His Life and Work*, London, 1980

EXHIBITION CATALOGUES

Camille Pissarro 1830-1903. Exhibition
catalogue, Hayward Gallery, London, Grand
Palais, Paris and Museum of Fine Arts,
Boston, 1981

Richard Thomson, *Camille Pissarro.
Impressionism, Landscape and Rural Labour.*
Exhibition catalogue, South Bank Centre,
London, 1990

GENERAL

*A Day in the Country. Impressionism and the French
Landscape.* Exhibition catalogue, Los Angeles
County Museum of Art, Art Institute of
Chicago and Grand Palais, Paris, 1984-5

The New Painting: Impressionism, 1874-86.
Exhibition catalogue, National Gallery of
Art, Washington and Palace of the Legion of
Honor, San Francisco, 1986

John Rewald, *The History of Impressionism*,
London, 1973

List of Illustrations

Colour Plates

1. The Banks of the Marne
 1864. Canvas, 81.9 x 107.9 cm.
 Glasgow City Art Gallery

2. The Donkey Ride at La Roche-Guyon
 1864-5. Canvas, 35 x 51.7 cm.
 Mr. Tim Rice, London

3. The Banks of the Marne at Chennevières
 1864-5. Canvas, 91.7 x 145.4 cm.
 National Gallery of Scotland, Edinburgh

4. A Square at La Roche-Guyon
 c.1867. Canvas, 50 x 61 cm.
 Nationalgalerie, Berlin

5. Still Life
 1867. Canvas, 81 x 99.6 cm.
 Toledo Museum of Art, Ohio

6. View of l'Hermitage at Pontoise
 1867. Canvas, 91 x 150.5 cm.
 Wallraf-Richartz Museum, Cologne

7. View of Pontoise: Quai du Pothuis
 1868. Canvas, 52 x 81 cm.
 Stadtische Kunsthalle, Mannheim

8. Lordship Lane, Dulwich
 1871. Canvas, 44.5 x 72.5 cm.
 Courtauld Institute Galleries, London

9. The Crossroads, Pontoise
 (Place du Vieux Cimitière)
 1872. Canvas, 55.8 x 91.5 cm.
 Museum of Art, Carnegie Institute, Pittsburgh

10. Pink Peonies
 1873. Canvas, 73 x 60 cm.
 Ashmolean Museum (Pissarro Gift), Oxford

11. Portrait of Jeanne
 1872. Canvas, 72.5 x 59.7 cm.
 John Hay Whitney Foundation, New York

12. A Road at Louveciennes
 1872. Canvas, 60 x 73.5 cm.
 Musée d'Orsay, Paris

13. The Entrance to the Village of Voisins
 1872. Canvas, 46 x 55.5 cm. Musée d'Orsay, Paris

14. The Hoar Frost
 1873. Canvas, 65 x 93 cm. Musée d'Orsay, Paris

15. Factory at Pontoise
 1873. Canvas, 46 x 54.5 cm.
 Museum of Fine Arts (James Philip Gray),
 Springfield Massachusetts Collection)

16. Portrait of Cézanne
 1874. Canvas, 73 x 59.7 cm.
 Private collection, London

17. Female Peasant Carding Wool
 1875. Canvas, 56 x 47 cm.
 E.G. Bührle Foundation, Zurich

18. The Little Bridge, Pontoise
 1875. Canvas, 65.5 x 81.5 cm.
 Stadtische Kunsthalle, Mannheim

19. The Pond at Montfoucault
 1875. Canvas, 73.5 x 92.5 cm.
 Barber Institute of Fine Arts, Birmingham

20. The Red Roofs, Corner of a Village, Winter
 1877. Canvas, 54.5 x 65.6 cm. Musée d'Orsay, Paris

21. Kitchen Garden with Trees in Flower,
 Spring, Pontoise
 1877. Canvas, 65.5 x 81 cm. Musée d'Orsay, Paris

22. The Diligence on the Road from Ennery to
 l'Hermitage, Pontoise
 1877. Canvas, 46.5 x 55 cm. Musée d'Orsay

23. The Outer Boulevards, Snow
 1879. Canvas, 54 x 65 cm. Musée Marmottan, Paris

24. Landscape at Chaponval
 1880. Canvas, 54.5 x 65 cm. Musée d'Orsay, Paris

25. The Harvest
 1882. Tempera on canvas, 71 x 127 cm.
 Bridgestone Museum of Art, Tokyo

26. Breakfast, Young Female Peasant taking
 her Coffee
 1881. Canvas, 63.9 x 54.4 cm.
 (Potter Palmer Collection), Art Institute of Chicago

27. The Little Country Maid
 1882. Canvas, 63.5 x 52.7 cm.
 Tate Gallery (Pissarro Bequest), London

28. The Poultry Market, Pontoise
 1882. Canvas, 115.5 x 80.6 cm.
 Norton Simon Foundation, Los Angeles

29. The Pork Butcher
 1883 Canvas, 65.2 x 54.3 cm.
 Tate Gallery (Pissarro Bequest), London

30. View from my Window, Eragny
 1886-8. Canvas, 65 x 81 cm.
 Ashmolean Museum (Pissarro Gift), Oxford

31. The Apple Pickers, Eragny
 1888. Canvas, 60 x 73 cm.
 Museum of Fine Arts (Munger Fund), Dallas

32. Two Female Peasants Chatting
 1892. Canvas, 89.5 x 116.5 cm. Metropolitan
 Museum of Art (Wrightsman Collection), New York

33. Young Woman Bathing her Feet
 1895. Canvas, 73 x 92 cm.
 Sara Lee Corporation, Chicago

34. Young Girl Mending her Stockings
 1895. Canvas, 65.2 x 53.8 cm.
 Art Institute of Chicago (Leigh B. Block Collection)

35. The Young Maid
 1896. Canvas, 61 x 49.9 cm.
 David Bensusan Butt, London

36. The Great Bridge, Rouen
 1896. Canvas, 74.3 x 92 cm.
 Carnegie Institute, Pittsburg Museum of Art

37. Boulevard des Italiens, Paris, Morning,
 Sunlight
 1897. Canvas, 73.2 x 92.1 cm. National Gallery of Art
 (Chester Dale Collection), Washington DC

38. La Place du Théâtre Français, Paris, Rain
 1898. Canvas, 73.6 x 91.4 cm.
 Institute of Fine Arts, Minneapolis

39. The Tuileries Gardens, Paris, Rain
 1899. Canvas, 65 x 92 cm.
 Ashmolean Museum (Pissarro Gift), Oxford

40. The Old Market and the Rue de l'Epicerie,
 Rouen, Morning, Grey Weather
 1898. Canvas, 81 x 65.1 cm.
 Metropolitan Museum of Art (Mr and Mrs Richard J.
 Bernhard Fund), New York

41. The Church of Saint-Jacques, Dieppe
 1901. Canvas, 54.5 x 65.5 cm. Musée d'Orsay, Paris

42. Harvest at Eragny
 1901. Canvas, 51.5 x 64.7 cm.
 National Gallery of Canada, Ottawa

43. Sunset at Eragny
 1902. Canvas, 73 x 92 cm.
 Ashmolean Museum (Pissarro Gift), Oxford

44. Dieppe, Duquesne Basin, Low Tide,
 Sun, Morning
 1902. Canvas, 54.5 x 65 cm. Musée d'Orsay, Paris

45. The Pilot's Jetty, Le Havre, Morning,
 Grey Weather, Misty
 1903. Canvas, 65 x 81.3 cm. Tate Gallery, London

46. The Pont Royal and the Pavillon de Flore,
 Paris
 1903. Canvas, 54 x 65 cm.
 Musée du Petit Palais, Paris

47. The Seine and the Louvre, Paris
 1903. Canvas, 46 x 55 cm. Musée d'Orsay, Paris

48. Self-Portrait
 1903. Canvas, 41 x 33.3 cm.
 Tate Gallery (Pissarro Gift), London

Text Figures

1. Tropical Landscape, St Thomas (Antilles)
 1856. Canvas, 27 x 35 cm.
 Mr. and Mrs. Paul Mellon, Philadelphia

2. Jean-Auguste Ingres:
 Bather
 1808. Musée du Louvre, Paris

3. Jean Baptiste Camille Corot:
 Quay at Le Treport
 c.1855-65. Oil on panel, 27 x 40.6 cm.
 Private collection

4. Crystal Palace
 1871. Canvas, 48 x 73.5 cm.
 Mr. and Mrs. Bensinger, Chicago

5. Paul Cézanne: Portrait of Camille Pissarro
 c.1874-77. Pencil on paper, 20 x 11 cm.
 Cabinet des Dessins, Musée du Louvre, Paris

6. Claude Monet:
 Waterlilies
 1908. 92 x 89 cm.
 Private collection, Zurich

7. Old Convent of Les Mathurins, Pontoise
 1873. Canvas, 59.7 x 73.3 cm. Private collection

8. Autumn Landscape, near Louveciennes
 c.1871-2. Canvas, 45.8 x 56 cm. Private collection

9. Orchard in Bloom, Louveciennes
 1872. Canvas, 45 x 55 cm. National Gallery of Art
 (Ailsa Mellon Bruce Collection), Washington DC

10. Spring
 1872. Canvas, 55 x 130 cm. Private collection

11. Summer
 1872. Canvas, 55 x 130 cm. Private collection

12. Autumn
 1872. Canvas, 55 x 130 cm. Private collection

13. Winter
 1872. Canvas, 55 x 130 cm. Private collection

14. Peasant Girl with a Stick
 1881. Canvas, 81 x 65 cm. Musée d'Orsay, Paris

15. Georges Seurat: Young Woman
 at her Toilette
 1889-90. Canvas, 94.5 x 79.2 cm.
 Courtauld Institute Galleries, London

16. White Frost, Woman breaking Wood
 1889-90. Canvas, 126.4 x 128.3 cm.
 Private collection

17. Turpitudes Sociales
 1890. Pen and brown ink on paper, 31.5 x 24.5 cm.
 Mr. Daniel Skira, Switzerland

Comparative Figures

18. Jean Baptiste Camille Corot:
 The High Ground at Sèvres on
 the Chemin Troyon
 1834-40. Canvas, 23.5 x 36.8 cm.

19. Gustave Courbet:
 Young Ladies of the Village
 1851. Canvas, 195 x 261 cm.
 Metropolitan Museum of Art, New York

20. Charles Daubigny:
 Banks of the River Oise
 Canvas. Musée des Beaux Arts, Bordeaux

21. Paul Cézanne:
 Still Life with Black Clock
 Canvas, 54 x 73 cm. Niarchos Collection, Paris

22. Claude Monet:
 The Gare Saint-Lazare, Paris
 1877. Canvas, 82 x 101 cm.
 Fogg Art Museum, Cambridge, Massachusetts

23. Eugène Boudin:
 The Beach at Trouville
 1865. Canvas, 18.5 x 26.6 cm. Private collection

24. Alfred Sisley:
 Chemin de Sèvres, Louveciennes
 1873. Canvas, 54.7 x 73 cm. Musée d'Orsay, Paris

25. Claude Monet:
 Train in the Snow
 1875. Canvas 59 x 78 cm.
 Musée Marmottan, Paris

26. Gustave Courbet:
 Covered Stream
 1865. Canvas, 94 x 135 cm. Musée d'Orsay, Paris

27. Winter at Montfoucault, Snow
 1875. Canvas, 114 x 110 cm.

28. Côte des Bœufs at l'Hermitage
 near Pontoise
 1877. Canvas, 114.9 x 87.6 cm.
 National Gallery, London

29. Claude Monet:
 Boulevard des Capucines, Paris
 1873-4. Canvas, 79.4 x 59 cm. Nelson Gallery,
 Atkins Museum, Kansas City, Missouri

30. The Poultry Market and Market Place
 at Gisors
 1885. Gouache and pastel on paper, 82 x 82 cm.
 Museum of Fine Arts (John Spaulding Bequest),
 Boston

31. Georges Seurat:
 A Sunday on the Grande Jatte
 1884-6. Canvas, 207 x 308 cm. Art Institue of
 Chicago (Helen Birch Bartlett Memorial Collection)

32. Study of a Young Woman bathing her Legs
 c.1895. Coloured chalks and pastel on paper,
 53.1 x 39.1 cm. Ashmolean Museum, Oxford

33. The Boieldieu Bridge, Rouen, Sunset
 1896. Canvas, 73 x 92 cm.
 City of Birmingham Art Gallery

34. The Rue de l'Epicerie, Rouen, Morning,
 Grey Weather
 1898. Canvas, 81 x 65 cm. Private collection

35. Portal of the Church of Saint-Jacques,
 Dieppe
 1901. Canvas, 78.5 x 65 cm. Private collection

1 The Banks of the Marne

1864. Canvas, 81.9 x 107.9 cm. Glasgow City Art Gallery

Pissarro arrived in France in 1855 at the age of twenty-six, having spent a relatively sheltered artistic life on the Danish island of St Thomas.

His arrival in Paris coincided with the last three or four days of the World Fair, which closed in November. Pissarro was very impressed by six paintings he saw by Camille Corot who, although he had been exhibiting at the Salon for a number of years, had only recently received critical acclaim. Pissarro decided to pay him a visit. Corot was very welcoming and although he did not admit pupils for formal tuition he had a small entourage of eager young protégés and encouraged Pissarro to join them. Pissarro enjoyed Corot's informal approach and valued his advice to such an extent that the first few times he exhibited at the Salon he described himself as 'pupil of Corot'; this was the case with this picture which was exhibited in 1864.

Banks of the Marne shows distinct reflections of Corot – the peaceful, serene landscape, the balanced composition and the use of the figure in the middle ground as a focus point to draw our eye along the track and into the picture. These same elements are found in Corot's *The High Ground at Sèvres on the Chemin Troyon* (Fig. 18).

Very few works from the 1860s still exist today, and those that do appear to lack the confidence that was obvious in the naturalistic canvases executed in St Thomas. It must be remembered that until his arrival in Paris, Pissarro had been accustomed to the company of only a very few other artists, and he suddenly found himself overwhelmed by a rush of new ideas from a group of influential and daring youngsters who were to become a revolutionary force.

Fig. 18
Jean Baptiste Camille Corot: The High Ground at Sèvres on the Chemin Troyon

1834-40. Canvas, 23.5 x 36.8 cm. Private collection

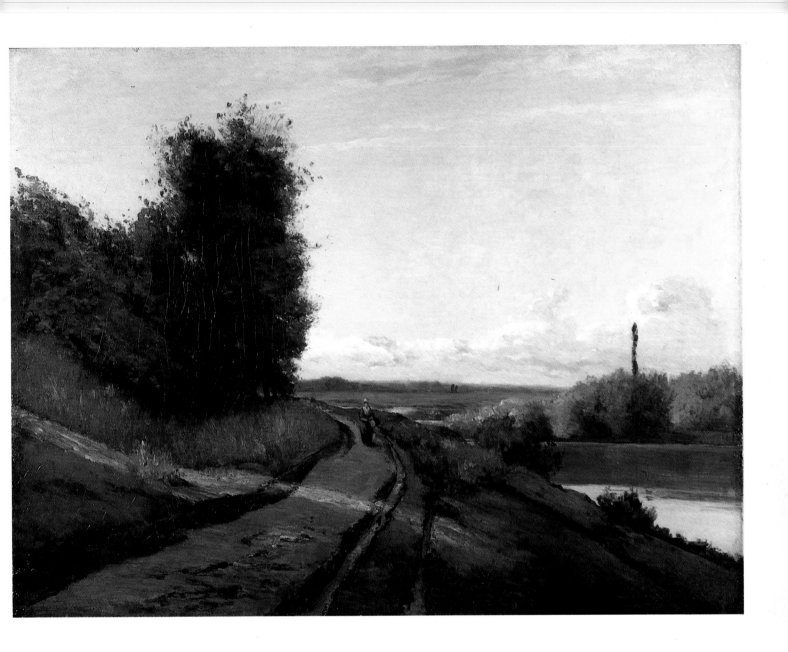

The Donkey Ride at La Roche Guyon

1864-5. Canvas, 35 x 51.7 cm. Mr. Tim Rice, London

Another artist whom Pissarro admired at the World Fair in 1855 was Gustave Courbet. Courbet's paintings, which had been rejected by the exhibition jury, were hanging in his own space just outside the entrance to the main hall. One work in particular caught Pissarro's eye. It was an enormous canvas measuring 195 x 261 cm., depicting three elegantly dressed ladies giving alms to a small girl in the middle of a field (Fig. 19).

The Donkey Ride draws its influences from Courbet's paintings in a number of ways. The compositional similarities are obvious: a group of figures in the foreground standing in a field with cows in the background. Both paintings also examine the social values of rural French society. Pissarro has suggested the division between the social classes, rather than depicting the physical transaction of money from one to the other. A bourgeois woman, dressed in white crinolines and a straw hat with a blue ribbon, is out with her equally well dressed children who are both seated on donkeys. These three figures are relaxed, content and confident. To the left of this group are two peasant children with ill-fitting clothes and bare feet. They stand close together as if frightened, shy or cold and stare in awe at the figures in front of them.

Pissarro's sympathies obviously lay with the poor if not slightly pathetic pair on the left. He draws our eye and our sympathy towards them by highlighting the small boy's white shirt and both their heads.

Fig. 19
Gustave Courbet: Young Ladies of the Village

1851. Canvas,
195 x 261 cm.
Metropolitan Museum
of Art, New York

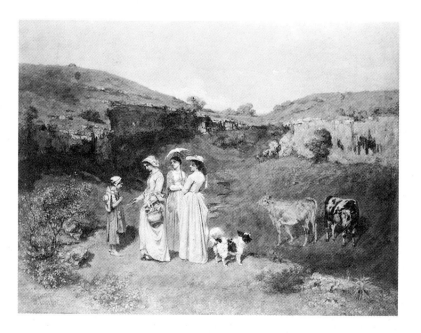

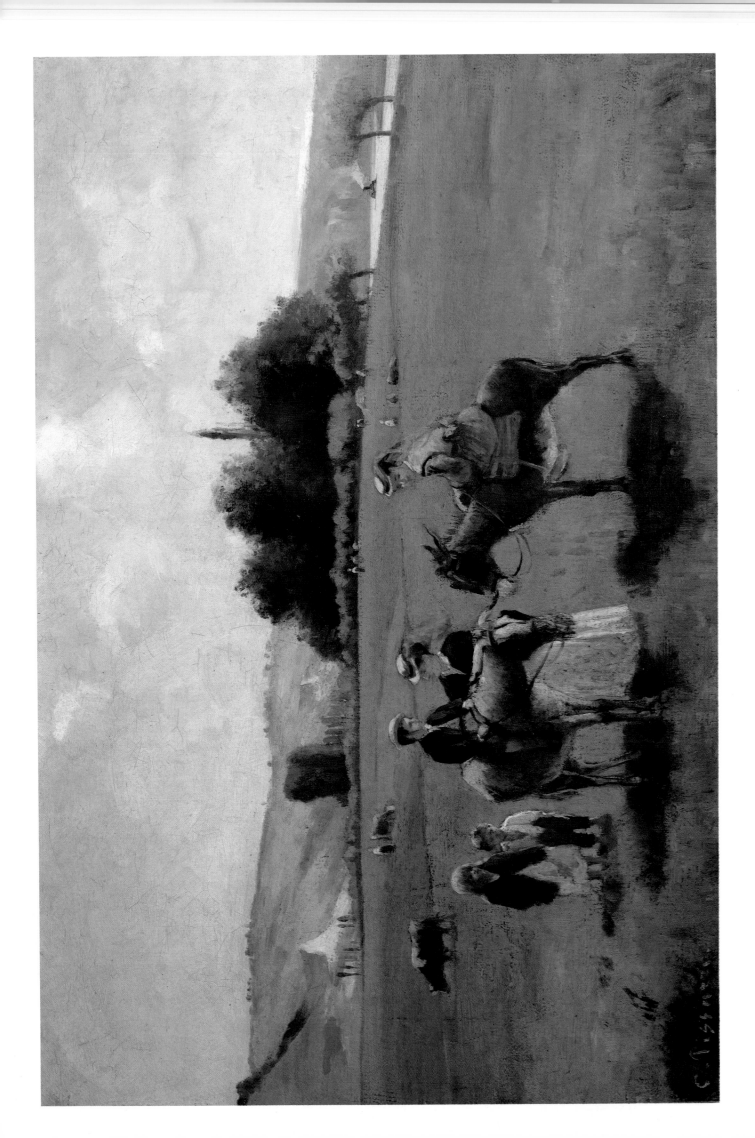

1864-5. Canvas 91.7 x 145.4 cm. National Gallery of Scotland, Edinburgh

Fig. 20
Charles Daubigny:
Banks of the River
Oise

Canvas. Musée des Beaux-
Arts, Bordeaux

When Pissarro's family returned to France from St Thomas they employed an additional servant, called Julie, to help in the house. Much against his parents' will, Pissarro was attracted to the girl, who was eight years his junior, and established a relationship with her. After a miscarriage in 1862 Julie gave birth to her first son, Lucien Camille, on 20 February 1863.

Preferring the countryside to the hustle and bustle of the city, Pissarro and his new family moved to Varenne Saint-Hilaire, a small village about 15 kilometres outside Paris on the banks of the River Marne. Across the river lies the village of Chennevières. We have seen in *The Banks of the Marne* (Plate 1) and *The Donkey Ride* (Plate 2) how Pissarro's sudden immersion in the artistic community of Paris caused him to be influenced by the artists he admired. Rather than be indebted to one particular artist, *The Banks of the Marne at Chennevières* demonstrates the technical influence of one and the compositional influence of another.

Following the example of Courbet, Pissarro has applied the paint, particularly in the large sections of water and sky, with a palette knife making the scene appear calm and serene. The subject and composition, however, are borrowed from Charles Daubigny. Daubigny was a successful landscape artist of the mid-eighteenth century. He was well known for his scenes of calm riverscapes, with delicate reeds standing out of the water and lucid reflections. His compositions were generally made up of two parts – water and sky – with an elegantly slim landscape dividing the two, as in *Banks of the River Oise* (Fig. 20). Pissarro has implemented the same approach in his own painting.

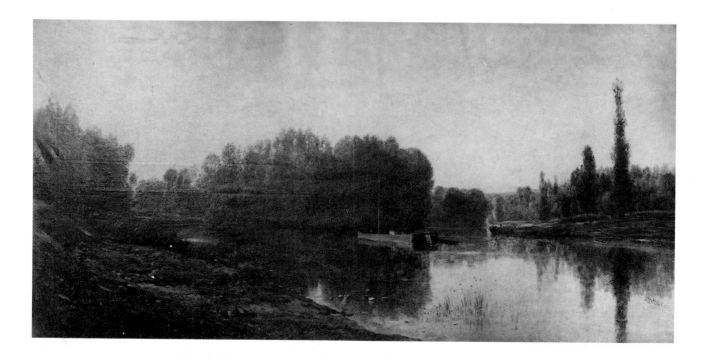

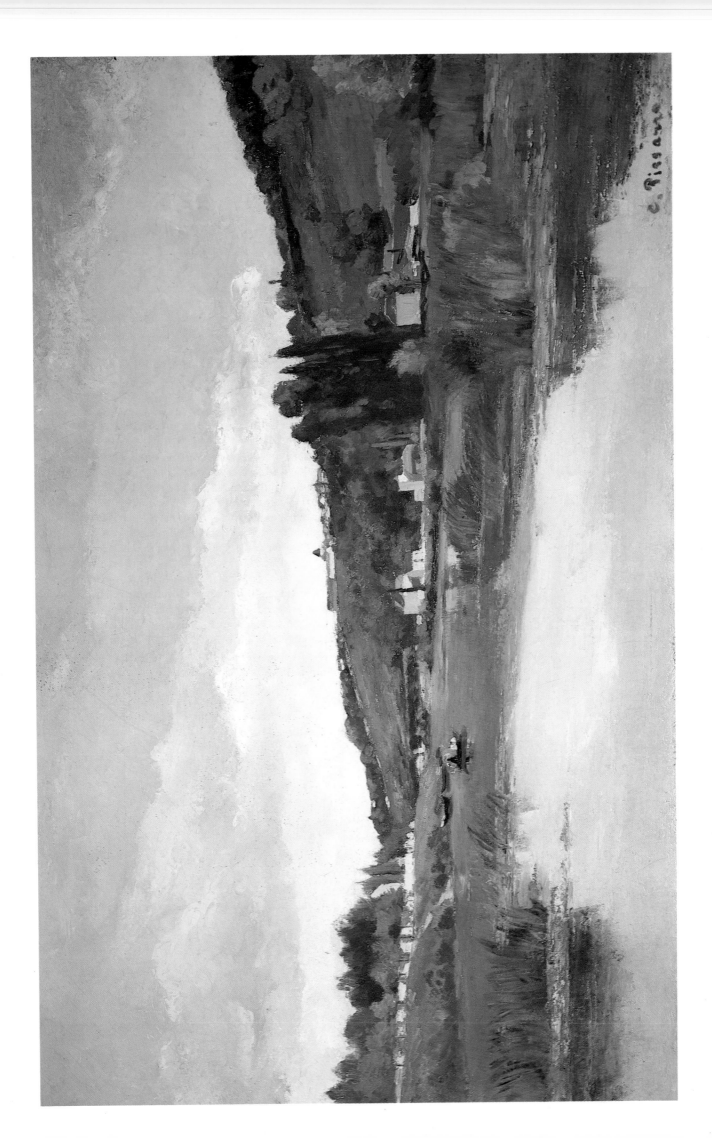

4 A Square at La Roche-Guyon

c.1867. Canvas, 50 x 61 cm. Nationalgalerie, Berlin

In 1866 only one of Pissarro's paintings was accepted by the Salon committee. Emile Zola, who had recently been appointed editor of the newspaper *l'Evènement* wrote a review of the picture and its creator: 'M. Pissarro is an unknown, about whom no one will probably talk. I consider it my duty to shake his hand warmly before I leave. Thank you, Monsieur, your winter landscape refreshed me for a good half hour during my trip through the great desert of the Salon. I know that you were admitted with great difficulty, and I offer my sincere congratulations. You should realize that you will please no one, and that your picture will be found too bare, too black. Then why the devil do you have the arrogant clumsiness to paint solidly and to study nature frankly... An austere and serious kind of painting, an extreme concern for truth and accuracy, a rugged and strong will. You are a great blunderer, sir – you are an artist that I like.'

Compared to some of the reviews Pissarro was to receive in later life, Zola's words were extremely flattering.

The young group of talented and eager artists, to which Pissarro was now associated, was desperate to exhibit their paintings but was constantly being rejected by the conservative committee of the Salon. In 1867 Monet suggested that he and his friends should rent their own space to show their pictures. The plan was received with great enthusiasm but failed due to a shortage of money. Pissarro's determination was not diminished by the lack of recognition he received, and he continued to work constantly. In the autumn of 1867 he received an invitaion from Antoine Guillemet asking him to join him at La Roche-Guyon. In his letter Guillemet explained that Cézanne would also be there. It is undeniable that Cézanne and Pissarro had great respect for each other. Although we have seen that Pissarro's use of the palette knife was influenced by Courbet, the method, use of colour and choice of subject in *A Square at La Roche-Guyon* are parallel to the works Cézanne executed there at the same time.

5 Still Life

1867. Canvas, 81 x 99.6 cm. Toledo Museum of Art, Ohio

Pissarro was first and foremost a painter of landscapes. His choice of subject here may have been the result of his close friendship with Cézanne, whom he had met in 1861 and who devoted a large portion of his work from about 1869-71 to painting still-lifes such as *Still Life with Black Clock* (Fig. 21).

Pissarro has assembled a group of simple objects from everyday French life of the mid-nineteenth century: a loaf of bread, a carafe of wine and a half-filled glass, some apples, a ceramic dish, a knife, a spoon and a ladle. These objects appear very sturdy, tangible and even heavy. Pissarro has been able to create this illusion of solidity by the use of a carefully composed but simple grid of horizontal and vertical lines. The brown band across the centre of the composition forms a strong, horizontal base line. This is reinforced by the fall of the tablecloth, the opposite table-edge and the expanse of ochre wall behind. The vertical lines are formed by the hanging ladle and reinforced by the glass and carafe. These axes serve to stabilize the composition while the bread and knife, diagonally placed across the grid, create an illusion of depth.

The three-dimensionality of the objects is also reinforced by the single source of light and the physical thickness of the paint. Light flows in from the lefthand side of the picture, catching the side and rim of the carafe and casting dark shadows on the tablecloth and wall. Throughout the painting, rather than use a brush Pissarro has applied the paint with a palette knife. The thick strokes are particularly visible in the hanging section of the tablecloth.

Fig. 21
Paul Cézanne:
Still Life with
Black Clock

Canvas, 54 x 73 cm.
Niarchos Collection, Paris

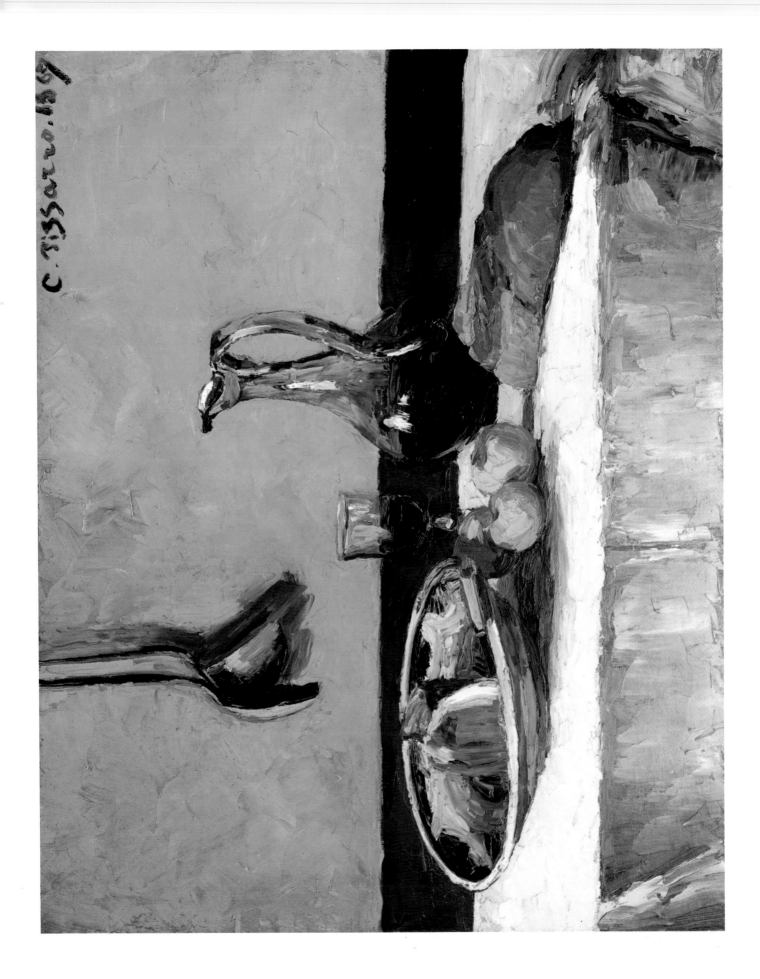

View of l'Hermitage at Pontoise

1867. Canvas, 91 x 150.5 cm. Wallraf-Richartz Museum, Cologne

Pissarro moved to Pontoise in 1866. Between then and 1883 he painted some 300 pictures of the town and surrounding countryside. Pissarro appears to have chosen Pontoise not for its unique terrain or natural beauty but because, unlike such places as Barbizon and Fontainebleau, it had not already been painted repeatedly by the landscape painters of the early half of the nineteenth century.

Between 1866 and 1868 Pissarro and his family lived in an area to the north east of town known as l'Hermitage. In this painting Pissarro is again experimenting with structure and form, as he did in the *Still Life* (Plate 5). Although perhaps more subtly, this scene is also composed of definite horizontal bands. These are suggested by the vegetable patch in the foreground, the large wall on the right and the smaller wall on the left in the middle distance, the band of fields and the large expanse of sky. The obliquely angled bed leading from the lower right corner gives an illusion of depth (as did the loaf of bread in the last plate) and, similarly, the composition is stabilized by the vertical pull of the tree trunks on the right and the buildings in the middle distance.

This painting was later to belong to Ambroise Vollard whom Pissarro met in 1894. Vollard owned a gallery at 39 rue Lafitte in Paris and Pissarro encouraged him to collect a number of different artists. He became known as one of the greatest dealers in Impressionist art.

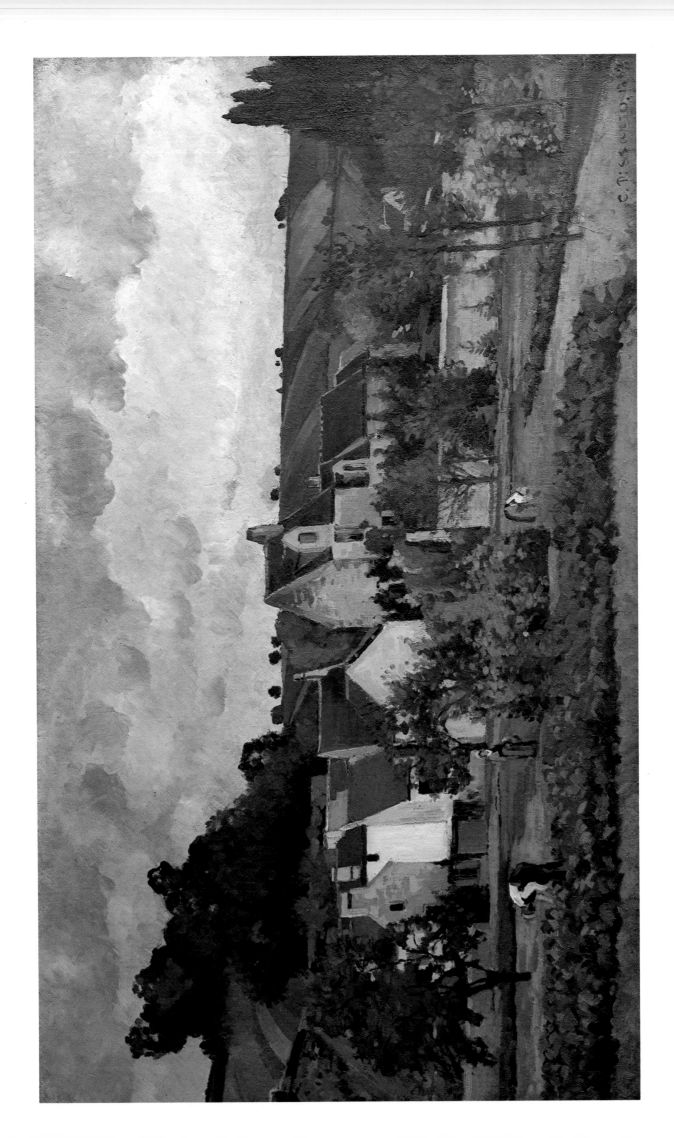

View of Pontoise: Quai du Pothuis

1868. Canvas, 52 x 81 cm. Stadtische Kunsthalle, Mannheim

We have seen how in the 1850s and early 1860s Pissarro depended on the works of other artists for subject matter, iconography and technique. However, as the 1860s progressed and his confidence grew, his works became bolder and more daring. Although he often returned to the technique of the palette knife that he had learnt from Courbet, he shed Corot's soft and gentle style and Daubigny's serene approach to nature.

View of Pontoise: Quai du Pothuis is an example of Pissarro's new-found confidence. His choice of colour and its application may be reminiscent of Courbet's sombre and monochromatic canvases, but the treatment of the subject and the structure of his composition are pure Pissarro.

Divided into strict horizontal bands, this composition makes social as well as artistic statements. Pissarro appears to have encapsulated the whole of society in this painting. First, and most obviously, we see a townscape, a road bordered with houses running along the side of a river. Behind the bridge in the middle distance Pissarro has placed a thick row of large trees suggesting the country. This is emphasized by the large expanse of sky which is usually found in pure landscape painting. Between the town and the country lies the industrial element – the tall, slim chimney emitting smoke bears witness to a productive factory. The apparently random figures are also emblematic of their social status. A bourgeois family walks in the middle of the road; a pair of factory workers push a wheelbarrow on the lefthand side and a peasant woman, denoted by her ubiquitous head-scarf, chats with a man on the left.

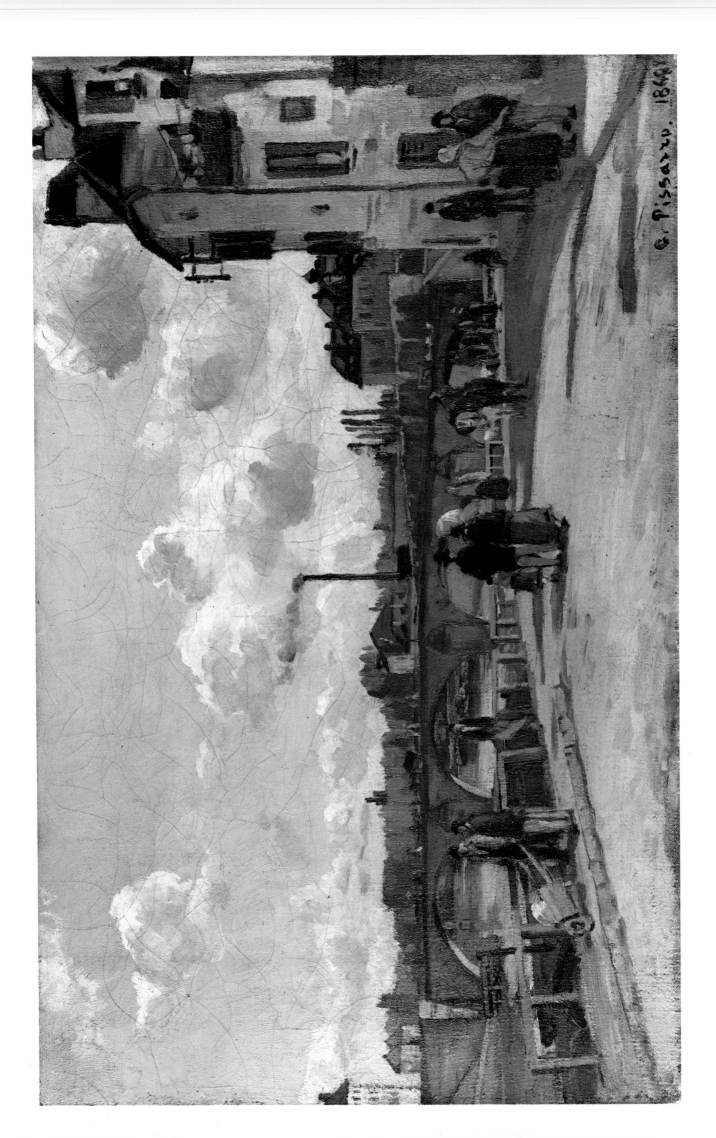

1871. Canvas, 44.5 x 72.5 cm. Courtauld Institute Galleries, London

France declared war against Prussia on 19 July 1870. Being Danish by birth, Pissarro was unable to fight and travelled to England, where he stayed with a relative in south London. While in England he met up with Claude Monet, who had also fled France to escape from the war.

They both spent their time productively, visiting art galleries and painting, but each concentrated on slightly different subject matter. Later, on his return to France, Pissarro commented: 'Monet worked in the Parks, whilst I, living at lower Norwood, at that time a charming suburb, studied the effects of mist, snow, and springtime'.

The importance of atmospheric effects to any Impressionist painter cannot be exaggerated. The same landscape or building was often depicted at different times of the day or year, to such an extent that the weather condition or time of day became more important than the church or street scene that was subjected to it.

The combination of atmospheric effects and the railway was examined by Monet in his series of paintings of the Gare Saint-Lazare six years later (Fig. 22). It had also been depicted by Joseph Mallord William Turner in his painting *Rain, Steam and Speed*, which Pissarro may have seen in the Tate Gallery during his stay in London.

Fig. 22
**Claude Monet:
The Gare Saint-
Lazare, Paris**

1877. Canvas, 82 x 101 cm.
Fogg Art Museum,
Cambridge, Massachusetts

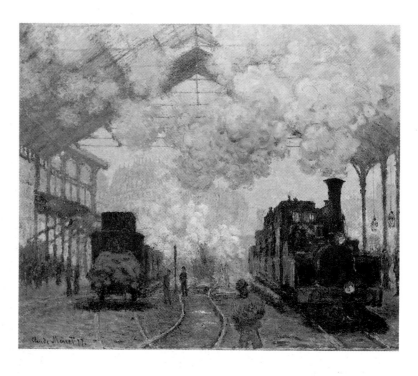

The Crossroads, Pontoise
(Place du Vieux Cimitière)

1872. Canvas, 55.8 x 91.5 cm. Museum of Art, Carnegie Institute, Pittsburg

Fig. 23
Eugène Boudin:
The Beach at
Trouville

1865. Canvas,
18.5 x 26.6 cm.
Private collection

While in London Pissarro had met the picture dealer Durand-Ruel, another refugee from the Franco Prussian War and the Commune of 1870-1. Durand-Ruel had been a great supporter of his compatriots, and even after Pissarro had returned to France in 1872 he exhibited nine paintings for him in London. These were the only pictures that Pissarro was to sell that year but, despite his financial difficulties, he did not stop painting.

The Place du Vieux Cimitière, now called the Place Saint Louis, is situated at the summit of the small hill on which Pontoise is built. It was used then, as it is today, as a market place, but Pissarro has chosen to depict it on a quiet day. The large expanse of blue sky is balanced by the brow of the hill in the foreground. The elegantly alternating band of buildings and trees across the centre of the composition is punctuated by the blue, yellow and red of the women's dresses. These figures appear to be influenced by Eugène Boudin's figures of women on the fashionable beaches of Trouville (Fig. 23).

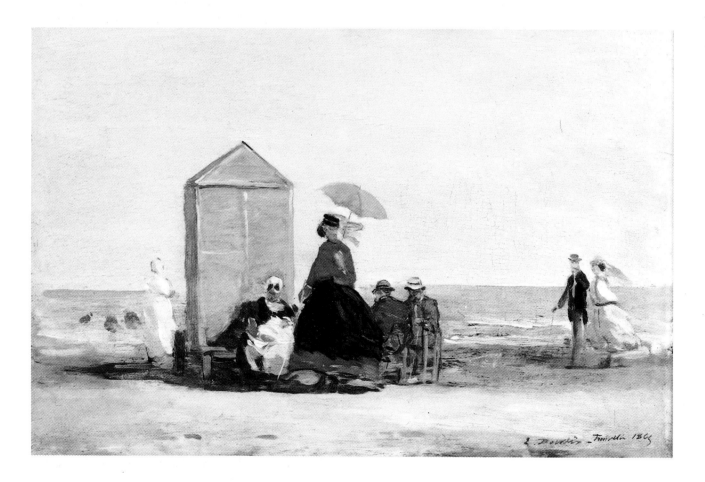

10 Pink Peonies

1873. Canvas, 73 x 60 cm. Ashmolean Museum (Pissarro Gift), Oxford

The year 1873 began well for Pissarro. On 13 January a large collection of paintings owned by the Hoschedé family was auctioned at the Hôtel Drouot in Paris, and Pissarro's landscapes sold for as much as 950 francs. However, his optimism did not last throughout the year; in October he complained about financial problems and he abandoned painting for a month to care for his daughter Jeanne who was seriously ill.

It is tempting to see a reflection of the fragile condition of his daughter's health in this still life. Cut flowers were traditionally used as a symbol of mortality, and Pissarro has deliberately reinforced this image through his technique. In comparison to Plate 5, *Pink Peonies* is pale and delicate. There are no stabilizing, horizontal lines to contrast with the wavering vertical form of the standing vase. Light seems to permeate the scene from all sides casting no shadows: the palette is much lighter and Pissarro has created a more feathery effect by choosing to apply the paint with a brush rather than a palette knife.

11 Portrait of Jeanne

1872. Canvas, 72.5 x 59.7 cm. John Hay Whitney Foundation, New York

Jeanne-Rachel sits in a pink-and-white striped dress, wearing a straw hat and holding a bunch of flowers in her lap. Her pose is totally relaxed and natural. However, she looks directly at us with her large, brown, innocent eyes as if she is slightly worried. Jeanne, also known as Minette, was Pissarro's second child and first daughter. She was born in 1862 and died two years after this painting was completed in 1874, at the age of nine. Pissarro has placed her in a lightly coloured room, close to the wall behind her but also very close to the picture frame. It was the first time he had brought his sitter so close. Traditionally, the entire figure would be placed in a room, visible from head to toe and surrounded by objects and space. Is it possible that Pissarro could sense the impending death of his daughter and was therefore more interested in her psychology than her physical presence?

In the course of his life Pissarro painted very few portraits. The people he chose to represent were exclusively members of his family or close friends.

A Road in Louveciennes

1872. Canvas 60 x 73.5 cm. Musée d'Orsay, Paris

Fig. 24
Alfred Sisley:
Chemin de Sèvres,
Louveciennes

1873. Canvas, 54.7 x 73 cm.
Musée d'Orsay, Paris

Pissarro moved to Louveciennes from l'Hermitage in the first half of 1869. It is possible that he made this change to be closer to Monet and Sisley, who were also painting there. In 1899, when Sisley became seriously ill, Pissarro wrote of him: 'He is a beautiful and great artist. I am of the opinion that he is a master equal to the greatest.'

While still in London, taking refuge from the war, Julie became pregnant again and was insistant on two things: first that the child should be born in France, and second that she and Camille should be married. Both requests were granted. A ceremony was held at Croydon Register Office and a second son, Georges Henri, was born at Louveciennes on 22 November 1872.

Pissarro had returned to France with his new and pregnant wife to find that their house had been requisitioned by the troops and pillaged. Of the 1500 works, representing twenty years' work, that he had left there, only forty remained. Despite their initial depression the couple quickly set to repair the house, and Camille was soon again roaming the countryside for new motifs. In the early 1870s he painted a number of horizontal works, where a broad road lined with trees and houses dominates the composition. Sisley also executed a number of similar works at about the same time. *Chemin de Sèvres, Louveciennes* (Fig. 24) was painted in 1873.

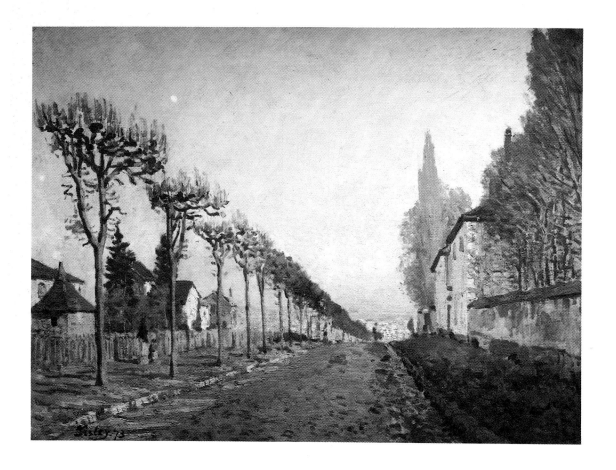

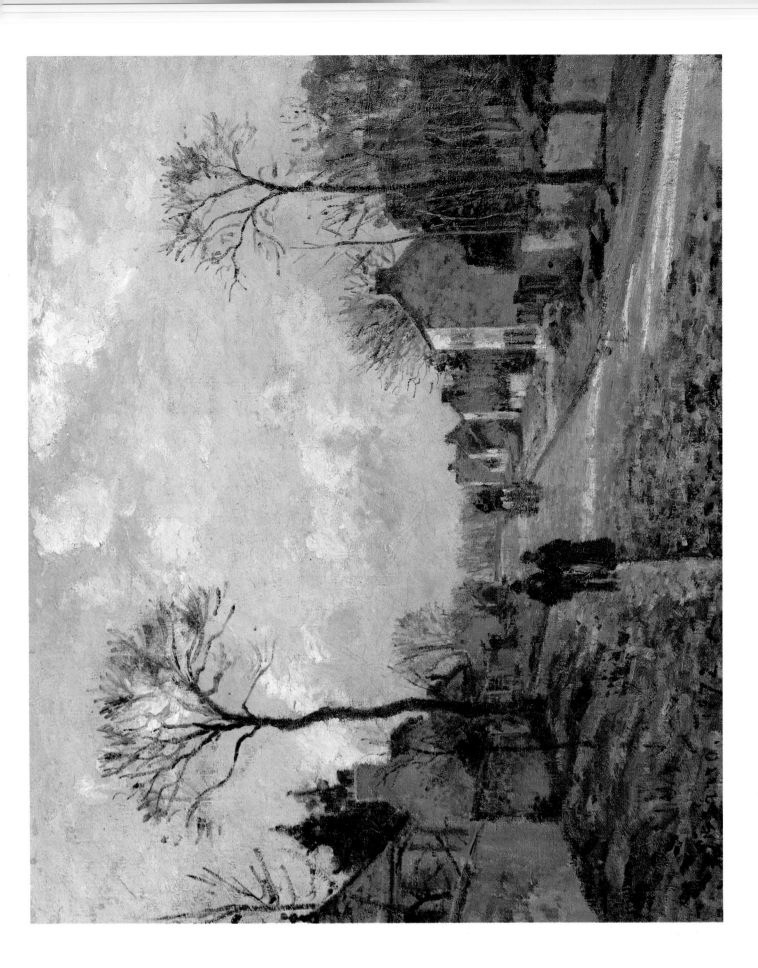

13 The Entrance to the Village of Voisins

1872. Canvas 46 x 55.5 cm. Musée d'Orsay, Paris

Although Pissarro painted some important pictures related to his stay in London, he and Julie were never very happy there. He wrote to his friend, the art critic Theodore Duret: 'I want to go back to France as soon as possible. Yes, my dear Duret, I will not stay here. It is only abroad that one feels how beautiful and how grand and how welcoming France is.'

Pissarro arrived in Louveciennes in June 1871 and stayed until April 1872, when he returned to Pontoise where he was to remain for the next ten years. Despite finding his house in disrepair he was overjoyed to be back on French soil, and at the beginning of 1872 his confidence flourished. He produced an enormous quantity of paintings and a variety of different and new motifs, and most important of all he was able to release himself from the sometimes very obvious links he had held with the older generation of artists.

In this painting Pissarro has depicted a calm, sunny, early spring day. The leaves are not yet out and the sun is still low, causing the tall slim tree trunks to cast long shadows across the path. As in *A Road in Louveciennes* (Plate 12) a road, bordered by walls and buildings, dominates the composition. Here, however, we are looking down, rather than up the street. Pissarro has achieved this view by lowering the horizon and exaggerating the height of the trees in the foreground.

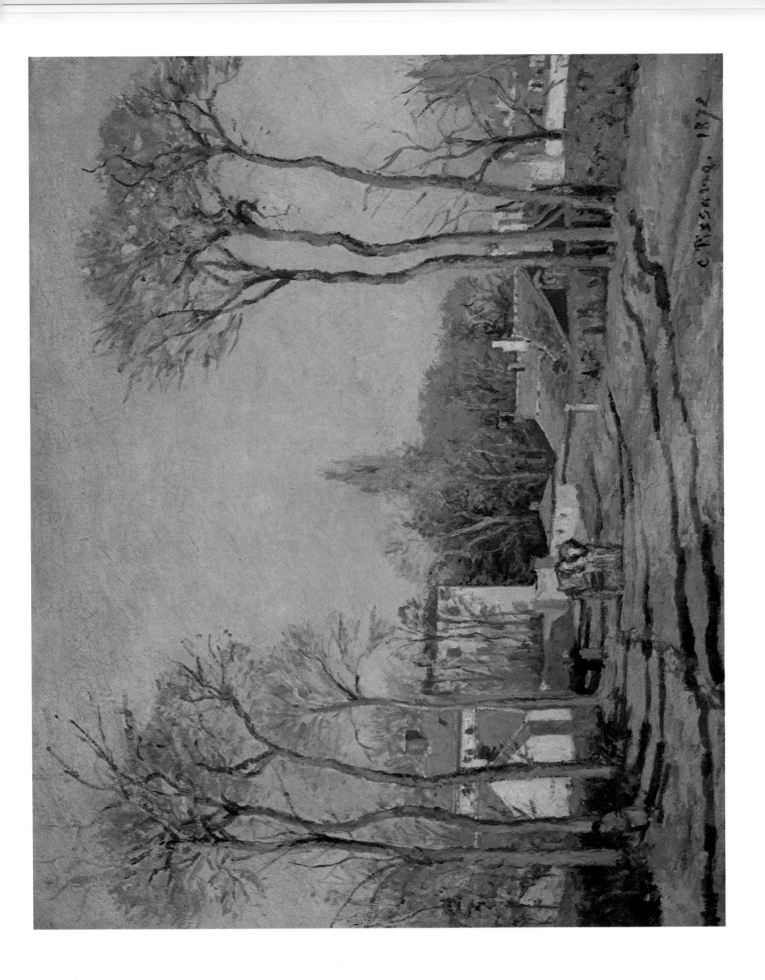

14 The Hoar Frost

1873. Canvas, 65 x 93 cm. Musée d'Orsay, Paris

The reinstitution of the first Salon since the Commune was announced in December 1871. Pissarro, Monet and Sisley, who did not agree with the new rules, refused to submit their work. Renoir presented a number of paintings only to be rejected by the jury, and since the Salon des Refusés had been discontinued he was unable to exhibit his work. In 1873 the same situation occurred, but as a result of the large number of rejected artists the Salon des Refusés was reinstated.

Pissarro was still not satisfied and devoted much thought to finding an alternative to the Salon. He imagined the best arrangement would be a society where artists could exhibit and sell their work independently, without the help of dealers, thus allowing each artist to exhibit as many paintings as he chose. Despite much discouragement, and warnings from his friends, Pissarro persisted with his plans and the formation of a co-operative society was announced in *La Chronique des Arts* on 17 January 1874.

The first exhibition, which opened for a month on 15 April 1874, was held at the studio of Nadar, the photographer, at 35 Boulevard des Capucines. Thirty artists exhibited at this, the First Impressionist Exhibition. Among them were Pissarro, Degas, Monet, Renoir, Morisot and Sisley.

The Hoar Frost was one of the five paintings that Pissarro chose to show. The crowds poured in, but very few of them were complimentary, most jeered and scoffed at what they saw, and this work was one of the many paintings ridiculed in the press. Louis Leroy, a journalist for *Le Charivari*, took a friend to the exhibition:

Then, very quietly, with my most naive air, I led him before the ploughed field of M. Pissarro. At the sight of this astounding landscape, the good man thought that the lenses of his spectacles were dirty. He wiped them carefully and replaced them on his nose.
'By Michalon!' he cried. 'What on earth is that?'
'You see … a hoarfrost on deeply ploughed furrows.'
'Those furrows? That frost? But they are palette scrapings placed uniformly on a dirty canvas. It is neither head nor tail, top nor bottom, front nor back.'
'Perhaps … but the impression is there.'
'Well, it's a funny impression!'

1873. Canvas, 46 x 54.5 cm. Museum of Fine Arts (James Philip Gray collection) Springfield, Massachusetts

The factory of Chalon et Compagnie is situated on the flat plains near Le Chou, and stands directly across the Oise from l'Hermitage where Pissarro lived. It was built in the early 1860s and extended between 1872 and 1873. When the extension was finished Pissarro used it as the motif for a series of four paintings. Although many of his contemporaries depicted stations, trains and other modern modes of transport (Fig. 25), Pissarro's canvases of the Chalon distillery exemplify the most thorough treatment of an industrial image by any member of the Impressionist group.

In reality, the factories in and around Pontoise merge relatively gently with the landscape that surrounds them. Here, Pissarro has painted his subject in such a way that, despite the size of the tree behind it, the factory appears to dominate its setting. Looking closely at the individual sections of the building, we notice that their proportions are unreal and that they do not appear to stand realistically in relation to one another. For example, the roof of the central shed looms over the parallel sheds beneath it at a strange angle. Pissarro is not interested in depicting a realistic image, but rather in creating an illusion of mass and size.

He makes the roofs appear haphazard to exaggerate their form and elongates the chimneys which churn smoke into the already cloudy sky. His most successful distortion, however, is created by the houses on the far left. These diminutive buildings are dwarfed by the enormous, industrial machine beside them. Here Pissarro has gone a step further. Rather than merely twist reality, he has invented. These dwellings did not exist.

Fig. 25
Claude Monet:
Train in the Snow

1875. Canvas 59 x 78 cm.
Musée Marmottan, Paris

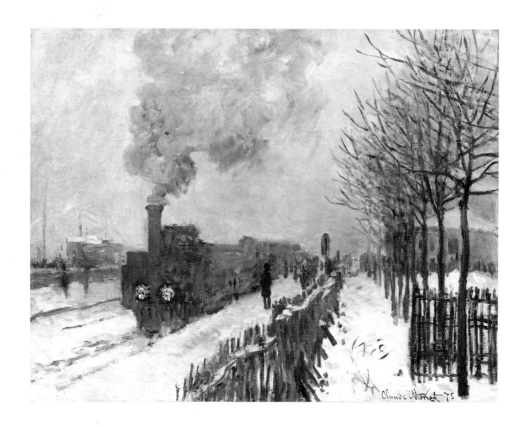

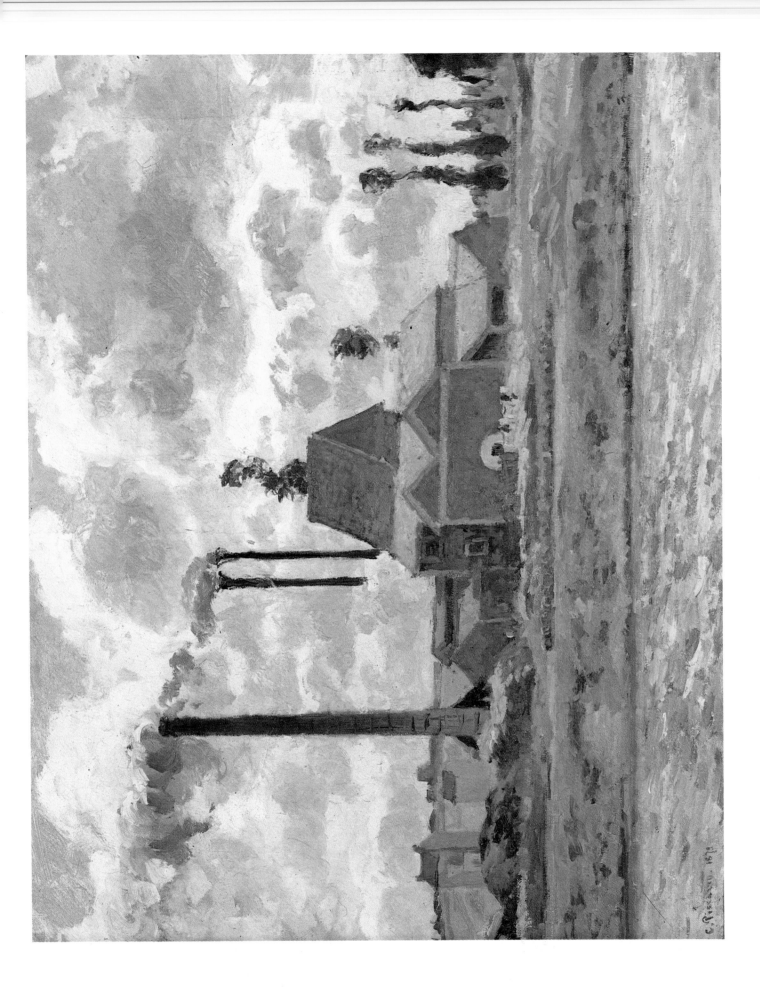

Portrait of Cézanne

1874. Canvas. 73 x 59.7 cm. Private collection, London

One afternoon in 1861, while making a tour of the Parisian Studios, Pissarro spotted the work of a young artist called Paul Cézanne. Pissarro encouraged the shy, disillusioned student and the friendship that ensued from this meeting became one of the most important relationships in the history of nineteenth-century painting. Pissarro would take Cézanne, nine years his junior, on his trips to the country and teach him to paint *en plein air*. Cézanne learnt much from Pissarro but their relationship was not one-sided; Pissarro also benefited from his contact with Cézanne.

In this portrait Cézanne is in Pissarro's studio in Pontoise, where the two artists worked in together in the 1870s. Contrary to the traditional portrait, Pissarro has not glamorized his sitter. Cézanne is dressed in informal clothes, similar to those he would have worn on their outdoor painting trips. At that time Lucien wrote to his brother Paul about Cézanne: 'His portrait painted by father resembles him. He wore a cap, his long black hair was beginning to receed from a high forehead, he had large eyes which rolled in their orbits when he was excited.'

Cézanne and Pissarro painted each other on a number of occasions, but this work appears to be the very first portrait of Cézanne by his friend. Although the painting is not signed, and perhaps not even finished (note the unpainted, lower edge of the canvas), it is possible to date the painting to 1874. We already know that the two artists were working together at this time, but looking at the picture more closely gives us further clues. Behind Cézanne, to the top left of the painting, is a contemporary, political caricature of Adolphe Thiers, then head of the French government. This print appeared in the newspaper *L'Eclipse* on 4 August 1874.

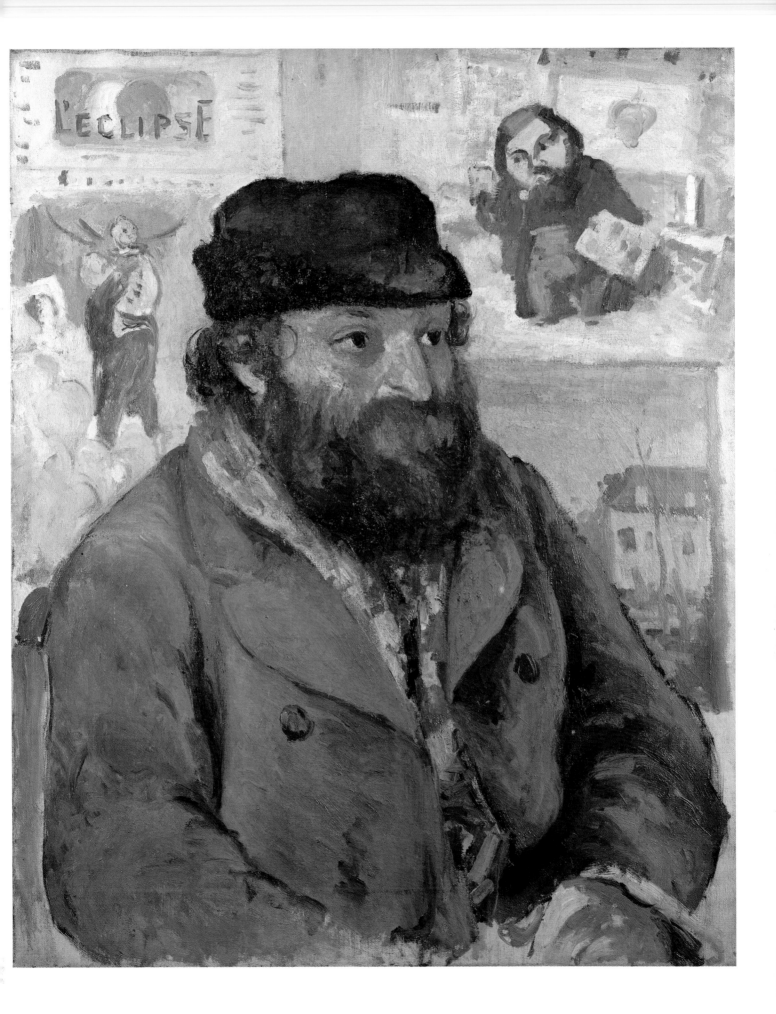

Female Peasant Carding Wool

1875. Canvas, 56 x 47 cm. E, G. Bührle Foundation, Zurich

1874 proved to be an emotionally exhausting year for Pissarro. He was distressed by the premature death of his daughter Jeanne (Plate 11) and depressed by the lack of understanding that he and the other Impressionists had received after their first exhibition.

It appears to have been as a result of these feelings that Pissarro turned away from the celebration of the French landscape, the examination of complex compositions and the treatment of structure and form. He reverted his attention to the artists who had influenced him on his arrival in Paris. He returned to the techniques he had learned from Courbet and paid homage to Jean-François Millet, who died in 1875.

Female Peasant Carding Wool suggests a more introspective approach. It is as if we have stumbled by accident upon this figure caught up in her thoughts. This image of deep concentration, as the woman picks up the wool from the basket and drops it on the other side of her lap is, however, not devoid of inventive compositional elements. The seated figure is placed directly in the centre and carefully framed on either side by two slim and very straight tree trunks. The painting is also symmetrical. The mass of foliage in the upper section of the composition, the twisting tree trunk, the torso of the woman and the expanse of wool as it tumbles to the floor, combine to form the shape of an egg timer. If we drew a horizontal line through the woman's arm and folded the page, the top and bottom of the 'egg-timer' would correspond almost exactly.

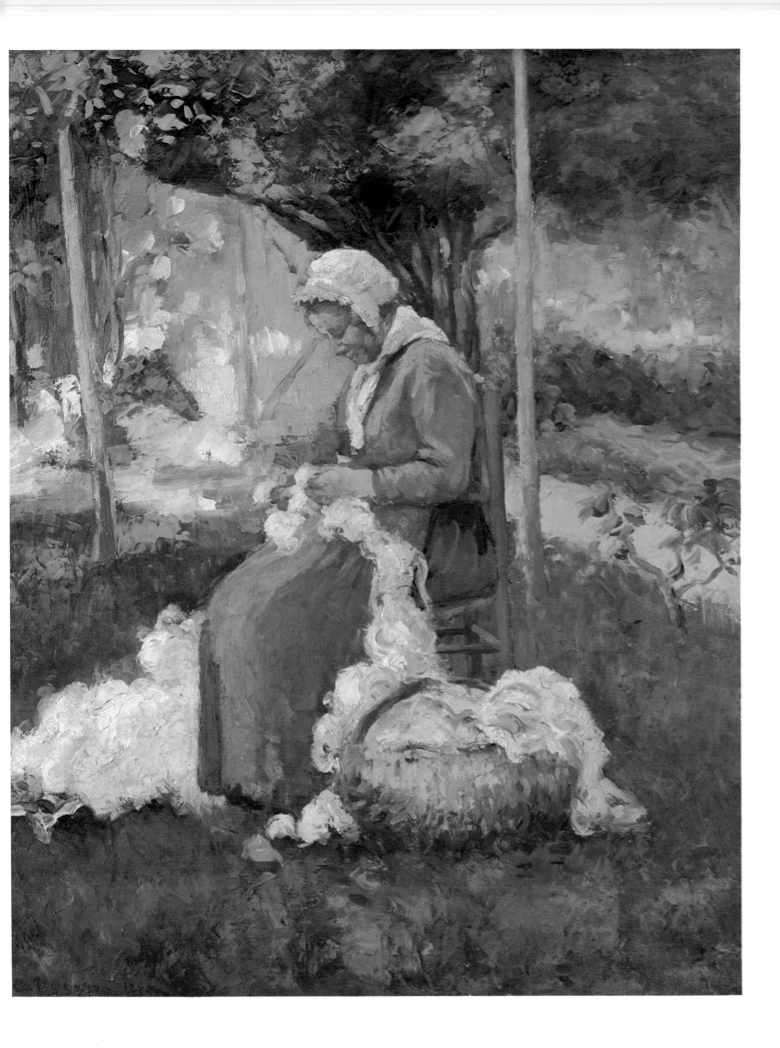

The Little Bridge, Pontoise

1875. Canvas, 65.5 x 81.5 cm. Stadtische Kunsthalle, Mannheim

Whereas Monet and Sisley tended to scour the countryside searching for a suitable view or composition, Pissarro generally chose systematically to record the landscape that surrounded his home. He appears to have depicted almost every aspect of the area, and to such an extent that his representations of Pontoise are rather like the concentric circles made by a stone when it hits the water's surface. Nevertheless, his pictures were not always without social comment. The countryside around Pontoise was littered with large houses and châteaux belonging to the *haute bourgeoisie* whom Pissarro held in complete contempt. Although he painted the grounds and surrounding landscape, he took great pains not to depict the buildings themselves.

The bridge in this painting stood in the grounds of the Château de Marcouville. By calling it simply *The Little Bridge*, Pissarro has chosen to avoid any suggestion of the grandeur associated with the château. It seems logical to ask why he should have depicted a scene which made it necessary for him to venture into the social territory he abhorred. It is possible, and indeed probable, that he was experimenting on a theme established by Gustave Courbet in the 1860s. In *Covered Stream* (Fig. 26) Courbet has similarly depicted water running through the dense undergrowth of a dark forest. In his own painting, some ten years later, Pissarro recreates a very similar setting and feel also using a palette of subdued greens and browns, applied in typical Courbet style with a knife rather than a brush.

It appears therefore that Pissarro's choice of subject could be dictated by the availability of a suitable site. It is possible that in the generally open and agricultural land around Pontoise this wooded area in the Marcouville grounds was the only spot where he could recreate the essential elements of Courbet's painting.

Fig. 26
**Gustave Courbet:
The Covered
Stream**

1865. Canvas, 94 x 135 cm.
Musée d'Orsay, Paris

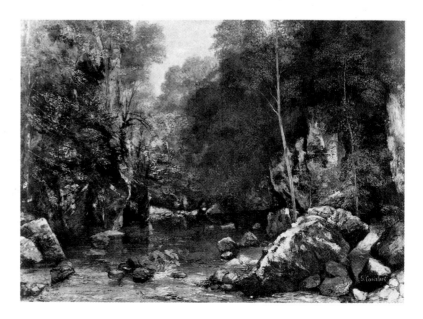

1875. Canvas, 73.5 x 92.5 cm. Barber Institute of Fine Arts, Birmingham

Fig. 27
**Winter at
Montfoucault,
Snow**

1875. Canvas,
114 x 110 cm.

Pissarro met Ludovic Piette in 1859 at the Académie Suisse in Paris, where both artists had enrolled in a course. Although not as well known as Pissarro, Piette exhibited regularly at the Salon in the 1860s and thirty of his paintings were shown at the Impressionist Exhibition of 1877. Piette lived at Montfoucault, a small village which lies on the border between Normandy and Brittany. He repeatedly invited Pissarro to come and stay, and as the Franco-Prussian War broke out in 1870 it was there that Pissarro and his family had taken refuge before crossing over to England.

Pissarro also spent the summer of 1874 with Piette, recovering from the stress and disappointment caused by the first Impressionist Exhibition in May that year, and after a short spell in Paris he returned to spend the winter at Montfoucault. It was during this stay that Pissarro concentrated closely on the image of peasant rural life; he made numerous paintings of female peasants engaged in their daily routines. He wrote to Theodore Duret of this new fascination: 'I haven't worked badly here. I have been tackling figures and animals. I have several genre pictures. I am rather chary about going in for a branch of art in which first-rate artists have so distinguished themselves. It is a very bold thing to do, and I am afraid of making a complete failure of it.'

The Pond at Montfoucault and *Winter at Montfoucault* (Fig. 27) are two of a number of paintings from 1875 depicting a cowgirl with her herd by the same pond on Piette's property.

1877. Canvas, 54.5 x 65.6 cm. Musée d'Orsay, Paris

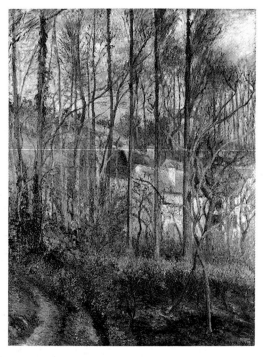

Fig. 28
Côte des Bœufs at
l'Hermitage near
Pontoise

1877. Canvas,
114.9 x 87.6 cm.
National Gallery, London

One of the earmarks of an Impressionist artist is that he painted in the open air. Instead of making a sketch or drawing of his subject and then working from memory back in his studio, he would set out into the countryside armed with an easel and canvas. Pissarro was a great supporter of this method and encouraged the younger artists to do the same. In 1877, however, he appears to have developed a technique of painting small oil sketches *en plein air* which he used as a basis for larger paintings. He considered the smaller compositions to be finished works of art, but they nevertheless served as a catalyst to create on a much larger scale. *The Red Roofs, Corner of a Village, Winter* is a relatively small canvas, compared to *Côte des Bœufs at l'Hermitage near Pontoise*, which measures 114.9 x 87.6 cm. It is possible that the latter is an extension of the former.

In this painting we see a small cluster of houses through the trees of an orchard. The buildings appear to be the subject of the painting, but the cobweb of trunks and branches stops the eye from resting on them for a second at a time. They physically block our view. Rather than being able clearly to look through and see the houses, our eye skids across the surface of the composition.

To paint *Côte des Bœufs at l'Hermitage near Pontoise* (Fig. 28) Pissarro has moved slightly up the hill and to the left. We can see that the building with the large brown roof and the small cream house in front of it have moved diagonally down the composition to the right, so that we see them from a slightly different angle. Here again, Pissarro has studied the myriad pattern of trees on the surface of the picture. The twisting branches in the foreground, and the vertical trunks in the middle distance and background, distract our eyes from the figures slowly walking through the undergrowth on the lefthand side.

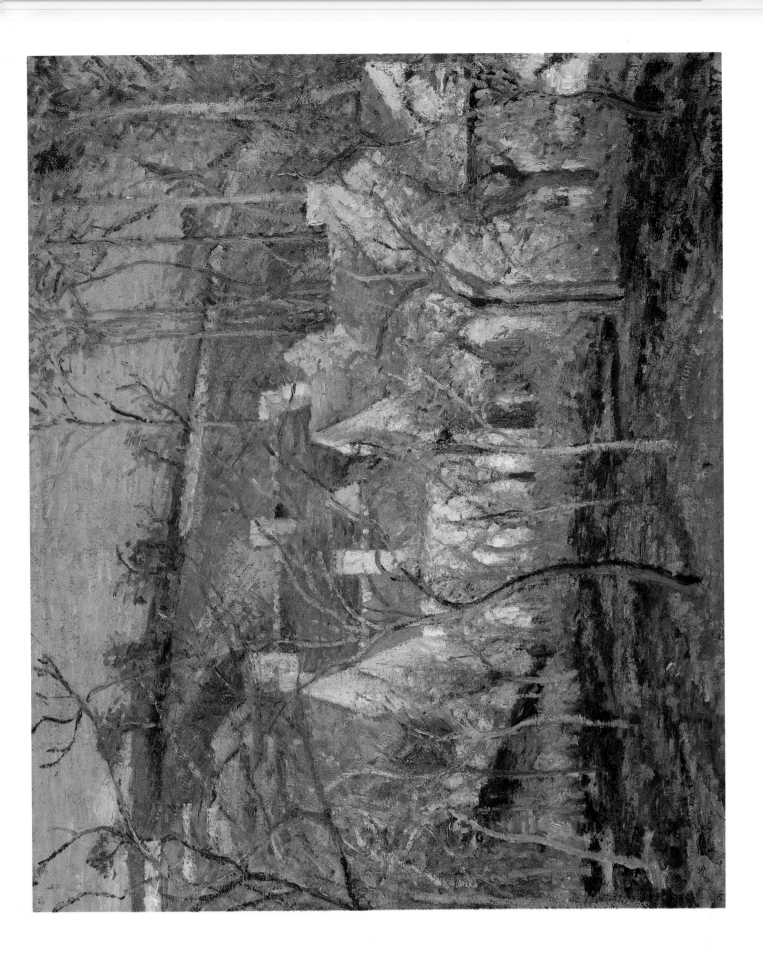

21 Kitchen Garden with Trees in Flower, Spring, Pontoise.

1877. Canvas, 65.5 x 81 cm. Musée d'Orsay, Paris

The titles of Pissarro's paintings are very rarely specific. They usually consist of a general description and a location. The detailed title for Plate 20, *The Red Roofs, Corner of a Village, Winter*, which appears to be original , must therefore be significant. It appears that Pissarro chose to paint the roofs on the Côtes Saint-Denis just when they had recently been retiled. Their distinctive colour obviously made a strong impression on him; he has not merely reproduced them but studied their redness in relation to that of the bushes, earth and ground around them. *Red Roofs* is a study in red.

Colour, and the technique with which it has been applied, is also significant in *Kitchen Garden with Trees in Flower*. Rather than dragging the paint along the canvas to create a smooth surface, Pissarro has quickly applied his brush, heavy with individual colours, to form dashes of pure pigment. The build-up of paint caused by this technique is so thick in parts, particularly in the white blossom, that it stands out in relief from the surface of the picture.

Cézanne, who on a number of occasions worked with Pissarro at Pontoise in the 1870s and 1880s, also painted this exact scene. There is no doubt that he assembled his easel next to Pissarro's and that the two artists worked side by side.

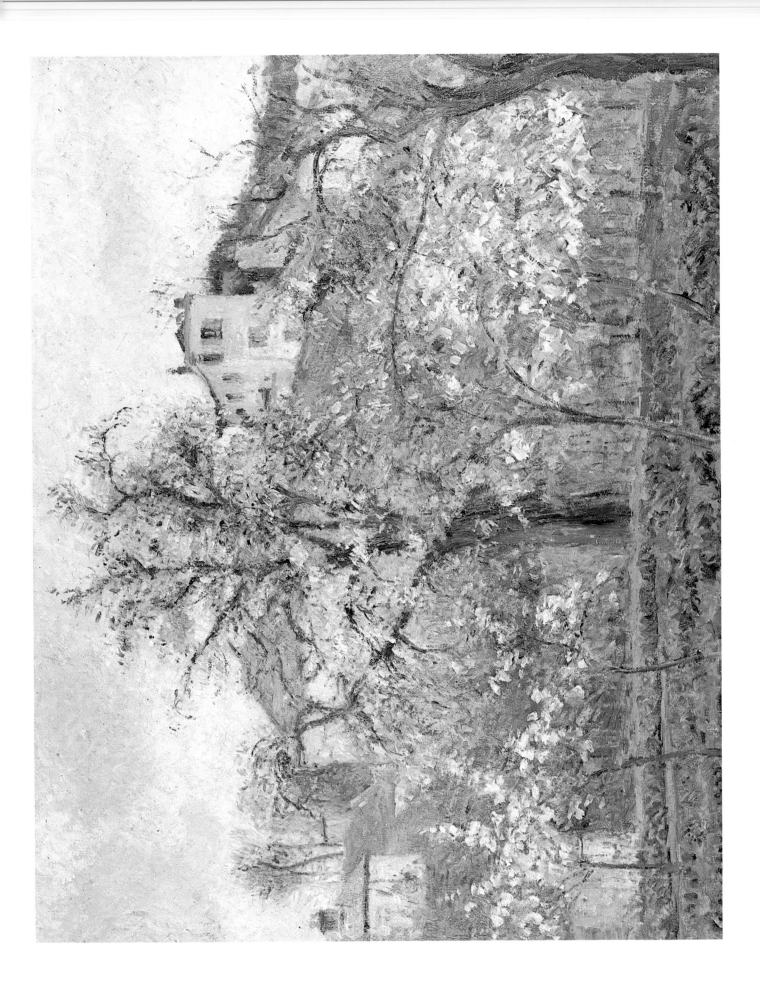

22

The Diligence on the Road from Ennery to l'Hermitage, Pontoise

1877. Canvas, 46.5 x 55 cm. Musée d'Orsay, Paris

This painting is similar in subject and composition to the paintings executed in 1872 in and around Louveciennes (see Plates 12 and 13). Again Pissarro has placed his canvas in a horizontal position and composed his painting around the basic elements of a road as the central axis, with buildings and trees on either side.

By 1877, the year when this picture was painted, the Impressionists were suffering from lack of respect and lack of remuneration, and were desperate to sell their works. They offered their paintings at reduced prices to any potential buyer and sometimes asked their friends for money. Renoir wrote to the publisher Charpentier: 'May I ask you if it is within possibility nevertheless, the sum of 300 francs before the end of the month ...' Monet also wrote to him: 'I am literally penniless here, obliged to petition to people, almost to beg for my keep, not having a penny to buy canvas and paints ...'.

Pissarro's situation was no different. He spent a great deal of time worrying about how to promote Impressionism and thinking of new ways to provide for his growing family. He did, however, have some constant supporters and buyers. Eugène Murer was introduced to Pissarro in 1872 by the artist Armand Guillaumin. Murer, who was a pastry cook, bought a painting as soon as he met Pissarro and continued to do so on a regular basis over the years that followed. This is one of the paintings that belonged to him.

In 1877 Murer decided to help Sisley and Pissarro by organizing a lottery which would offer a painting as the first prize. So little interest was generated by the event that hardly anybody turned up on the day of the draw, which was therefore postponed until the next day, 5 November 1877. The winner was a young girl who was so disappointed with her prize that she made it clear to Murer that she would prefer to have a cream bun rather than the picture. Her request was granted and, to his satisfaction, Murer was able to keep the prize.

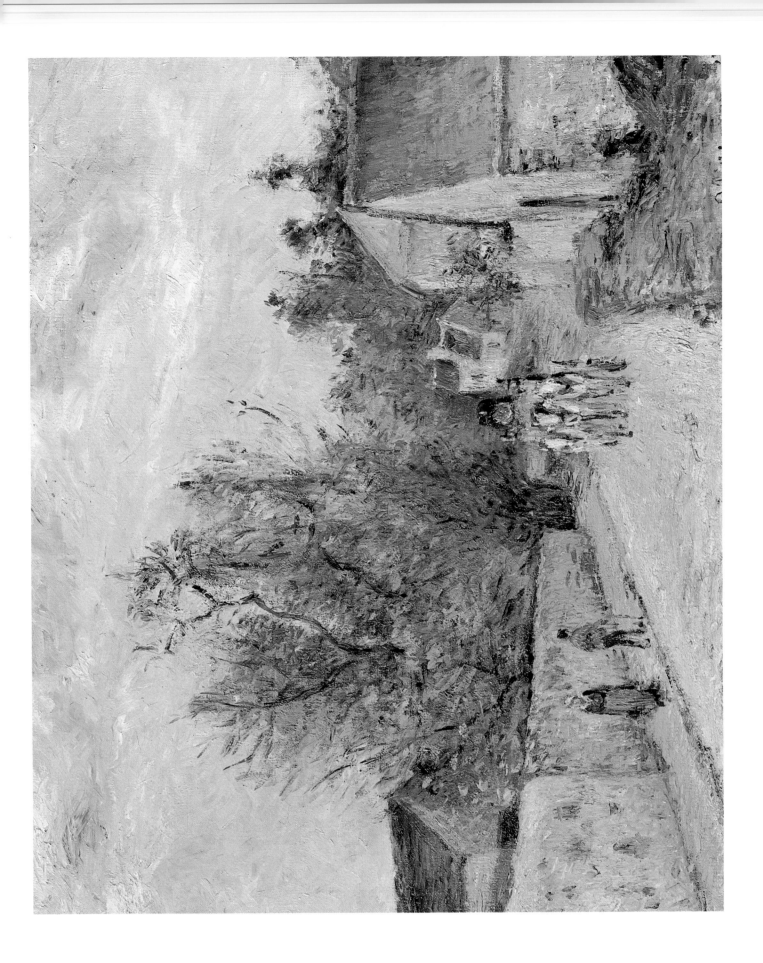

1879. Canvas, 54 x 65 cm. Musée Marmottan, Paris

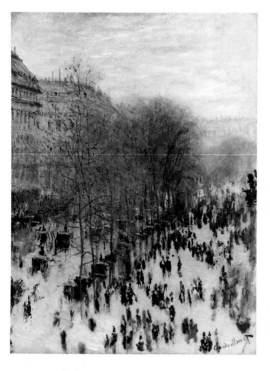

Fig. 29
Claude Monet:
Boulevard des
Capucines, Paris

1873-4. Canvas,
79.4 x 59 cm.
Nelson Gallery, Atkins
Museum, Kansas City,
Missouri

In September 1878 Julie gave birth to another son. He was named Ludovic Rodolfe after Piette, who had died the previous year. This new addition to the family made Pissarro all the more determined to provide for his wife and children. Later in the same year, he found a studio in Paris. In November he wrote to Theodore Duret: 'I am moving next Tuesday to no. 18 rue des Trois Frères, Paris. I shall do everything I possibly can to scrape up a little money.' He did not, however, find his new lodgings suitable either for painting or for showing works to potential clients, and became decidedly depressed in his new surroundings.

In the 1890s Pissarro would begin a series of paintings devoted to the Parisian boulevards. This subject is therefore unusual in a work from 1879 and appears to be influenced by Claude Monet's *Boulevard des Capucines*, dated 1873 (Fig. 29). Although both artists depicted a similar view, with an avenue of trees on the lefthand side, the effect of each is very different. Monet's boulevard is stylish and elegant while Pissarro's is grey and miserable. Pissarro has created this effect in a number of ways. The scene is definitely a cold one. The few figures on the street are huddled in overcoats or under umbrellas, protecting themselves from the elements. The small figure in the foreground, with his head bowed and hands in his pockets, sums up the mood of the picture. Pissarro is also able to exaggerate the gloomy effect by keeping his viewpoint very close to the level of the street. In the 1890s his viewpoint rose dramatically, giving an impressive view of his subject. Rather than glorify the streets as Monet has done, and he himself was later to do, Pissarro's *Outer Boulevards* appears to reflect his inner feelings.

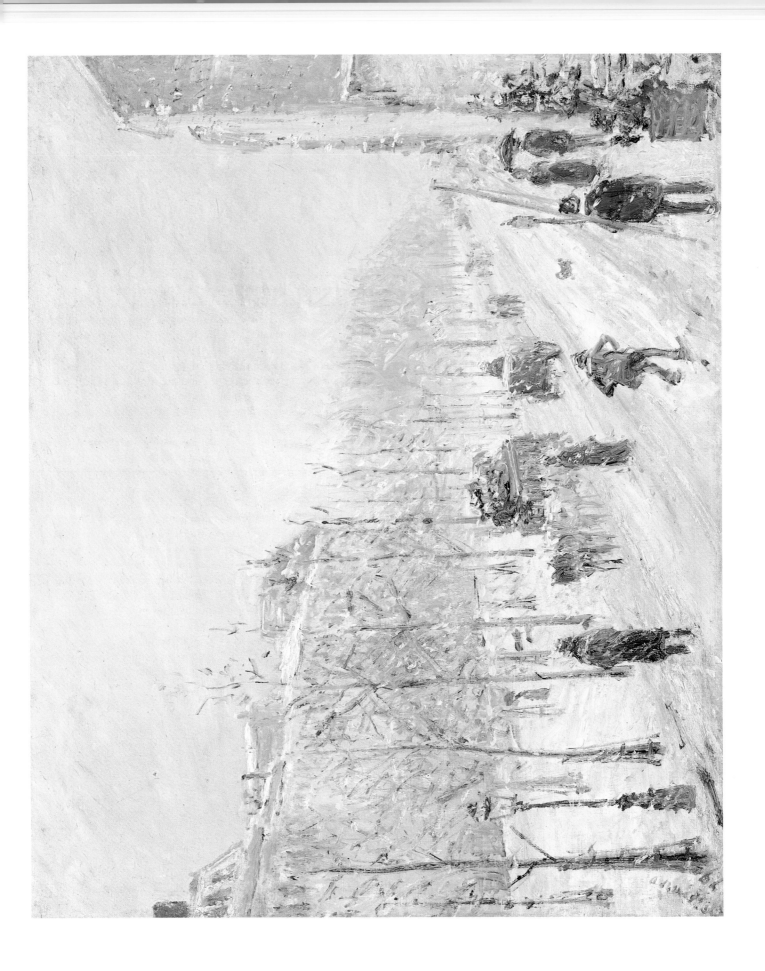

1880. Canvas, 54.5 x 65 cm. Musée d'Orsay, Paris

The Fourth Impressionist Exhibition was held in Paris at 28 avenue de l'Opéra and opened on 10 April 1879. Pissarro, who was the only artist to include works in all seven exhibitions, submitted thirty-eight works. Renoir, Sisley and Cézanne, who felt disillusioned by the lack of recognition they had achieved, did not participate. Despite the diminishing numbers of the original group from the First Impressionist Exhibition, Pissarro was keen to continue with the series and the subsequent fifth and sixth shows were held with a year's gap in between, in 1880 and 1881.

The derision and lack of understanding continued, perpetuating the financial hardship of almost all the Impressionist painters. It also gave Pissarro the time to reconsider the direction his painting was taking. Until now he had been concerned with the recession of space and his compositions had been carefully structured into the basic elements of foreground, middleground and background (see Plates 5 and 6).

In *Landscape at Chapponval* Pissarro pushes the formation of horizontal bands to the extreme. Rather than giving an illusion of reality and depth, the painting is almost abstract in its composition. The bands made up of field, houses, hill and sky seem almost to sit on top of one another, rather like the figures in a medieval tapestry. The figure also seems to play a different role. Rather than being merged into the landscape, the cow girl and her charge stand resolutely in the central foreground and demand our attention. Pissarro's use of blue was also significant in his approach to the abstract, and caused a certain reaction from the critics. Not only are the sky and girl's dress blue, but so too are the roofs of the houses. A year later Pissarro wrote to Lucien: 'Here in Osny, I devote myself exclusively to painting, and besides I feel a little desire to read those external criticisms. If in London we are being reproached for showing unfinished work – here we are accused of having sick eyes "the sickness of the painters who see blue".'

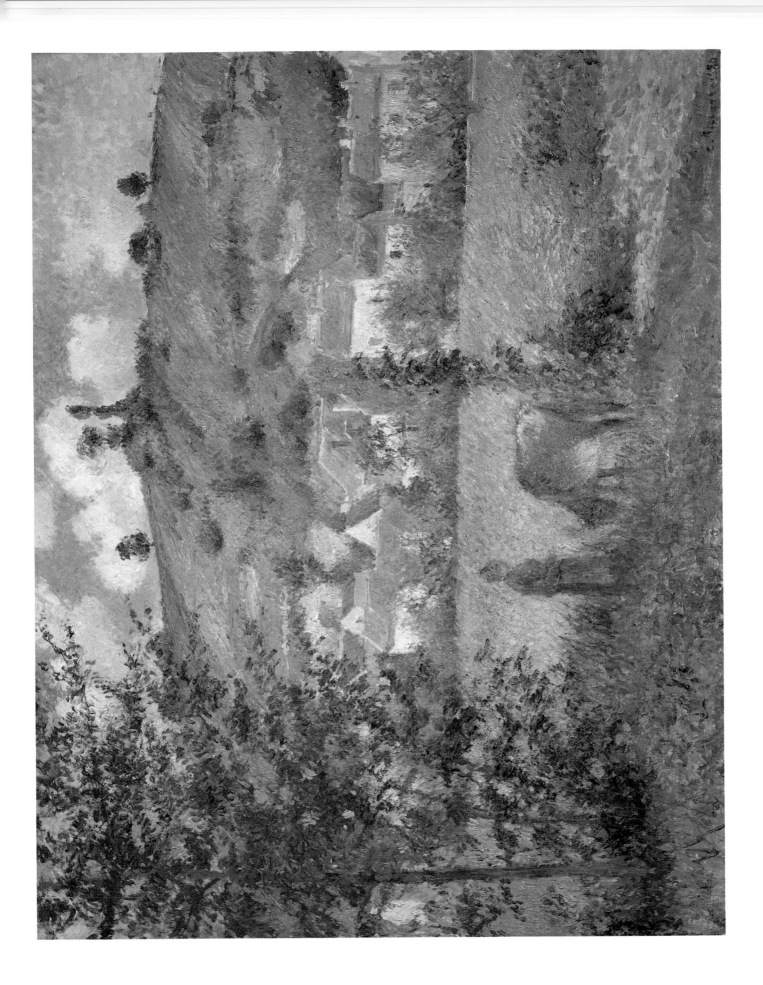

The Harvest

1882. Tempera on canvas, 71 x 127 cm. Bridgestone Museum, Tokyo

Pissarro's third daughter was born on 27 August 1881. She was named after her sister Jeanne (see Plate 11) who had died in 1874. This addition to the family made Julie all the more aware of the family's financial needs and she insisted that Lucien, her eldest son, find some form of employment. Pissarro himself, who was encouraging his son's artistic talents, was not eager to see Lucien go into business and therefore allowed him to remain at home to help with the framing of his pictures and the organization of exhibitions. As it happened, Pissarro could not have continued without his son's help. The support and encouragement of his contemporaries was waning and, as a result the Seventh Impressionist Exhibition appeared to cause more headaches than the previous ones. It did finally take place at 251 rue Saint-Honoré in March 1882 and, with the exception of Degas, all the mainstream Impressionists were represented.

The Harvest was one of the thirty-six works that Pissarro chose to exhibit. By carefully positioning his figures on and around the receding lines of piles of hay, Pissarro has created a peaceful and rhythmical composition. Eight figures, four men and four women, are preparing the harvest. The concentration of figures on the lefthand side causes an imbalance in the composition, thus making our eye fix immediately on the standing woman wearing a red headscarf. The bushel of hay that she is holding is placed at an angle, leading from the corner of the picture and pointing towards the wide, open landscape on the righthand side.

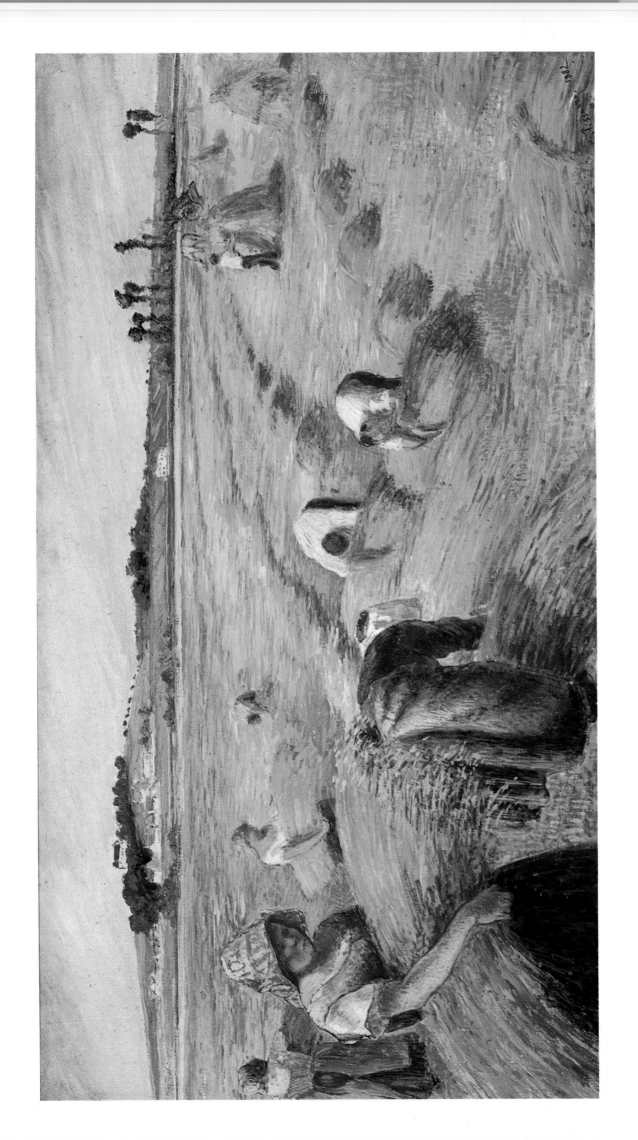

26 Breakfast, Young Female Peasant taking her Coffee

1881. Canvas, 63.9 x 54.4 cm. Art Institute of Chicago (Potter Palmer Collection)

A young woman sits in a bare room carefully stirring her coffee. Her blue skirt and brown blouse tell us that she is a peasant. Light enters the room through an open window on the lefthand side and gently falls on the woman's chest, hands, face and the nape of her neck. Pissarro has composed this simple scene carefully. The heavy, bent arm of the young woman fits neatly into the lower lefthand corner of the picture. The same shape is echoed, on the lefthand side, by the 'L' shape formed by the window frame and the wall beneath the window. Through the window we see the suggestion of trees, perhaps an orchard. The bright colour of the foliage outside recurs in a small dab of paint inside suggesting the handle of the mug.

On 19 October 1883 Pissarro mentioned this painting in a letter to Lucien: 'I showed my studies to Morel. He responded by exclaiming: "Ah! Ah! – Look at that! – Strange! – Interesting!", etc. I don't believe he likes my pictures, however he told me that when he saw my *Peasant Girl taking her Coffee*, he thought it so fine that he wanted to write and tell me so, but he did not know my address. He called it flawless.'

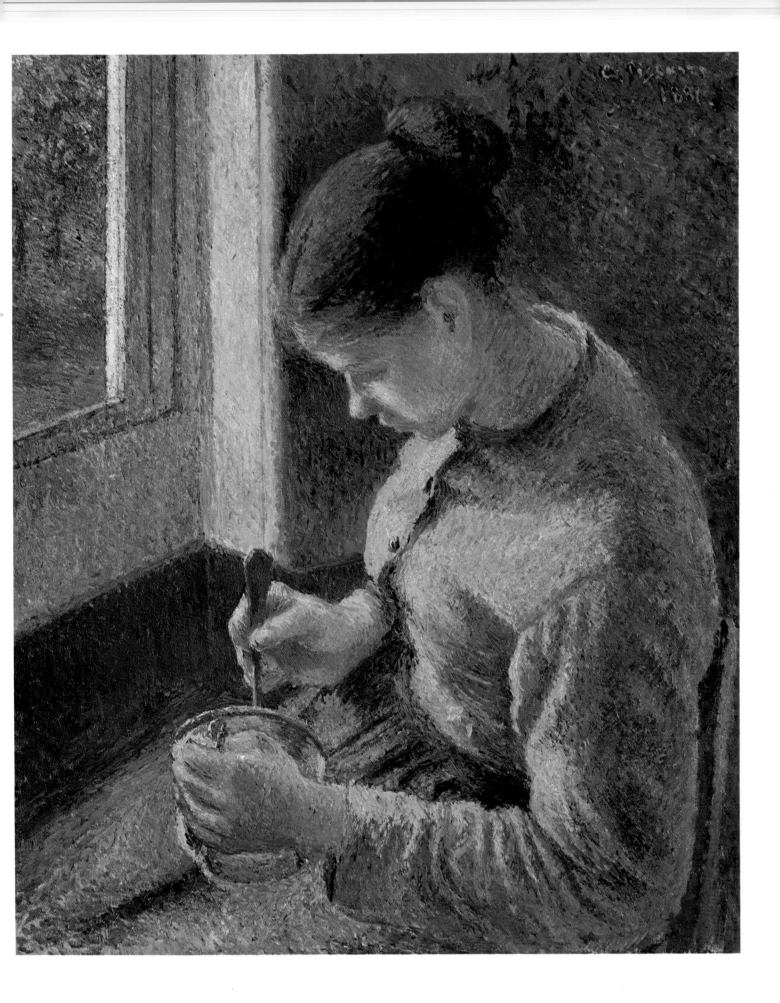

The Little Country Maid

1882. Canvas, 63.5 x 52.7 cm. Tate Gallery (Pissarro Bequest), London

Pissarro has depicted an apparently simple, domestic interior. A maid is quietly brushing the floor, while a small child seated at a table eats his breakfast. Although the composition focuses on a figure involved in a physical action the scene is totally static. The moment has been held, rather like a snapshot. Pissarro has achieved this stillness by surrounding the people in the picture with a variety of inanimate, recurring shapes. The circular forms of the teapot and cup and saucer are reflected in the round curve of the table, the chair backs and the waist and skirt of the maid. The strong vertical lines of the doorway are reinforced by the legs of the chair in the foreground and the parallel sides of the picture frames, while the band of carpet on the floor is reinforced by the cornice, and the whole is anchored by the diagonal brush handle. The immobility of these objects and their careful placement in conjunction with each other enforce a static quality on the figures, making the painting literally a still-life.

It has been suggested that this type of composition was influenced by Degas, who also had a tendency to place figures at the very edge of the canvas as if they had been cut off by the picture frame. The small boy seated at the table is almost certainly Pissarro's son Ludovic-Rodo, who would have been four when this painting was executed. In later years Ludovic-Rodo was to compile the *catalogue raisonné* of his father's works, with the help of Lionello Venturi.

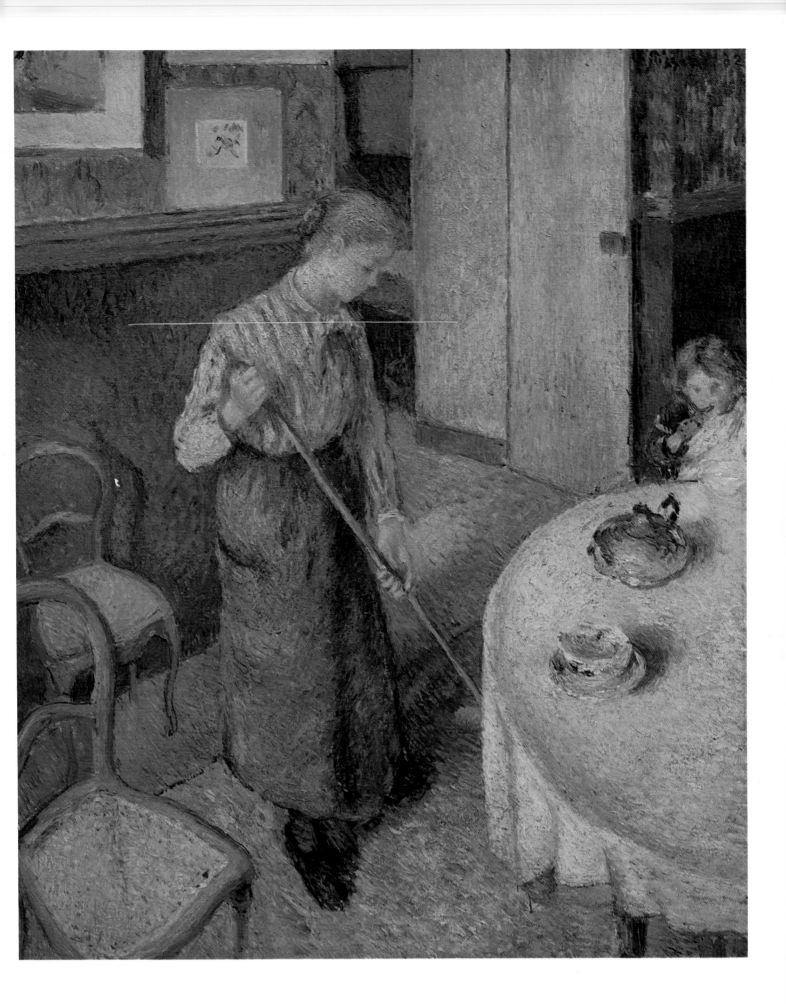

The Poultry Market, Pontoise

1882. Canvas, 115.5 x 80.6 cm. Norton Simon Foundation, Los Angeles

In 1882 Camille and Julie decided that their eldest son, Lucien, who was then twenty years old, should go to England to learn English. Pissarro was concerned for his son, an artist like himself, and for the next twenty years sent him almost daily letters with advice, support and comments on what was happening at home. This tender, intelligent and informative correspondence has become one of the most important records of the Impressionist era.

Pissarro's interest in market scenes began in the 1880s, and over the following fifteen years he executed innumerable drawings, gouaches and temperas of the subject, although only five oils. There were a number of markets in and around Pontoise, and Julie and her husband must have frequented them on a regular basis to feed their large family. Pissarro's choice of subject was not merely expedient, however. We have seen in Plates 2 and 7 how he was commenting on social and rural life. Pissarro was fascinated by the market because it was here, with the exchange of produce for money, that the true transaction between peasant and bourgeois took place.

In *The Poultry Market and Market Place at Gisors* (Fig. 30), we see peasants selling eggs, geese and hens, their bare or scarved heads contrasted with the straw hats of the buying bourgeoisie.

Fig. 30
Market Place at Gisors

1885. Gouache and pastel on paper, 82 x 82 cm. Museum of Fine Arts (John Spaulding Bequest), Boston

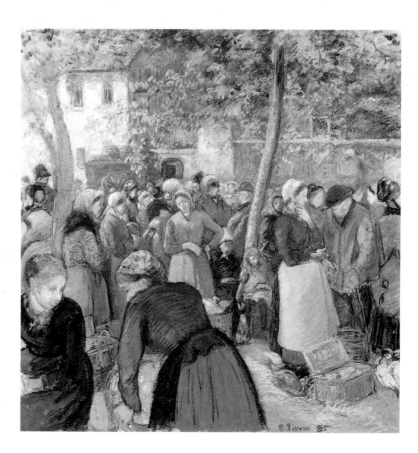

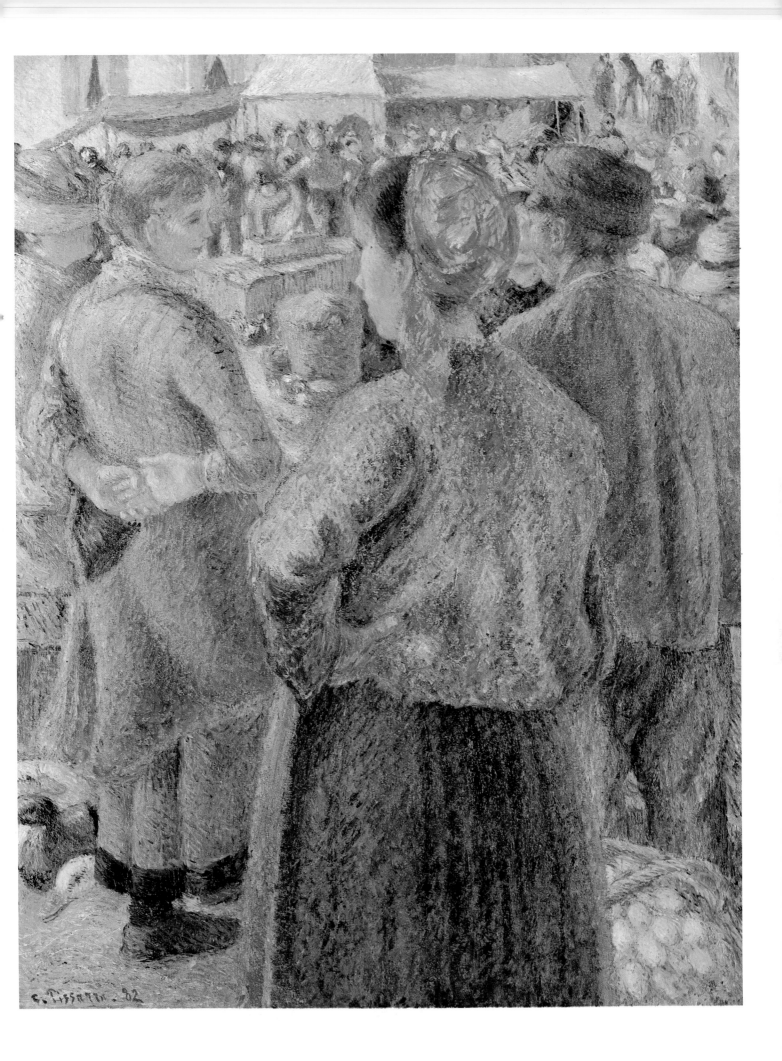

C. Pissarro. 92

The Pork Butcher

1883. Canvas, 65.2 x 54.3 cm. Tate Gallery (Pissarro Bequest), London

In the summer of 1883 bad weather prevented Pissarro from painting outside. He moved his working place from the wide open countryside to the crowded and bustling environment of the market place. Pissarro has crushed the figures and stalls close together, bringing them nearer to the surface of the picture and making us feel part of the scene. Our eye dashes around the composition, looking first at the butcher herself (who was Nini, Pissarro's niece) the cuts of meat on the table, the striped shirts and scarved heads of the figures on the left and finally to the woman in the blue skirt on the righthand side. Much thought and consideration went into this composition. Pissarro wrote to Lucien on 20 February: 'I do not budge from here; I work as much as I can on the landscapes I have started and on my picture *The Market*, which I have changed completely.' X-rays reveal that the figure with the long blue skirt on the righthand side was originally looking at the butcher's wares on the table. This simple glance put too much emphasis on the central figure, creating an effect of static movement rather than of the bustling scene we now see.

In July Pissarro wrote again to Lucien: 'I haven't done much work outdoors this season, the weather was unfavourable, and I am obsessed with a desire to paint figures which are difficult to compose with. I have made some small sketches; when I have revolved the problem in my mind, I shall get to work. I had Nini pose as a butcher's girl at the Place du Grand Martoy; the painting will have, I hope, a certain naive freshness. The background, that's the difficulty. We shall see.'

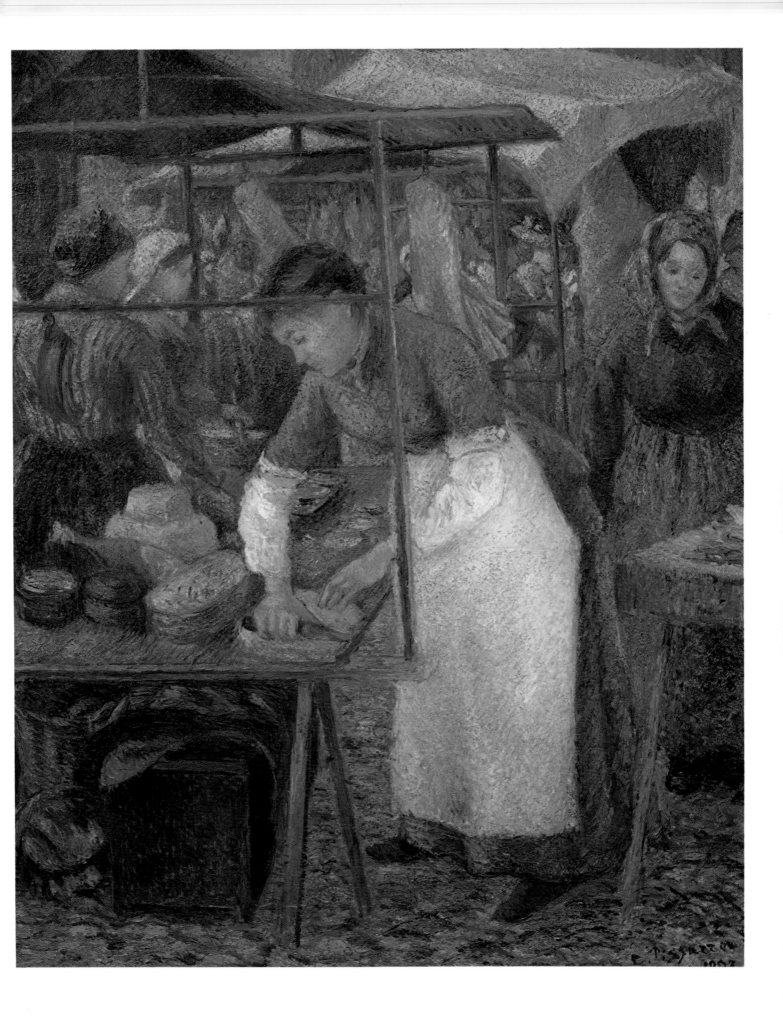

1886-8. Canvas, 65 x 81 cm. Ashmolean Museum (Pissarro Gift), Oxford

By 1884 Pissarro had already fathered six children and Julie was pregnant again. The family urgently needed a more spacious place to live, and Pissarro went in search of a house. He looked in l'Isle-Adam which he disliked, Gisors which he enjoyed and finally Eragny-sur-Epte, not far from Gisors, where he found a reasonably sized house with a huge garden and fields, for 1000 francs.

The entire family was overjoyed with their new surroundings. The children had plenty of room in which to play, Julie was pleased with the space and garden and Camille had an entire new range of views and motifs to discover. In this painting, Pissarro has depicted the view from his room across the fields looking towards the river Epte and the small village of Bozincourt. The painting appears to have been signed and dated twice. The date 1886, which has been overpainted, was found to the right of the now-visible signature. This discovery suggests that the painting referred to in Camille's letter to Lucien of 30 July 1886 was this one: 'My *Grey Weather* doesn't please him; his son and Caseburne also dislike it. What kills art in France is that they only appreciate works that are easy to sell. It appears that the subject is unpopular. They object to the red roof and back yard – just what gave character to the painting which has the stamp of a modern primitive ...'.

1888. Canvas, 60 x 73 cm. Museum of Fine Arts (Munger Fund), Dallas

Fig. 31
Georges Seurat:
A Sunday on the
Grande Jatte

1884-6. Canvas,
207 x 308 cm.
Art Institue of Chicago
(Helen Birch Bartlett
Memorial Collection)

As part of the natural development of his technique Pissarro had started using small, tightly grouped brushstrokes in his paintings of the late 1870s (see Plate 22). In the mid and late 1880s he was able to develop this further. In 1885 he met Georges Seurat, who was twenty-nine years his junior and consciously developing a scientific technique whereby he could obtain greater luminosity and a more precise control of tone and colour. In *A Sunday on the Grande Jatte* (Fig. 31), painted between 1884 and 1886, Seurat applied small dots of pure colour on the surface of the painting. Although at close quarters the technique and physical build-up are obvious, at a certain distance the eye fuses the dots to form solid colour.

Pissarro grasped this new approach as a way out of the impasse into which he felt Impressionism had fallen. But despite his enthusiasm, very few of his contemporaries were as convinced as he. Monet could not sympathise with such an unemotional and scientific method. Renoir, who disliked theories of any kind, dismissed the new trend light-heartedly, while Julie, who felt her husband had at last gained respect in the art world, could not understand why he wanted to be labelled a revolutionary again. Pissarro persisted however, and devoted a number of canvases to the pointillist technique.

Pissarro painted a number of scenes of the apple harvest. Here, a man knocks the branches of a tree to release the apples which are being collected by two crouching women. Another woman looks on intently, her hands held up to her face. Pissarro's juxtaposition of dots of pure colour creates the effect of a warm afternoon towards the end of summer.

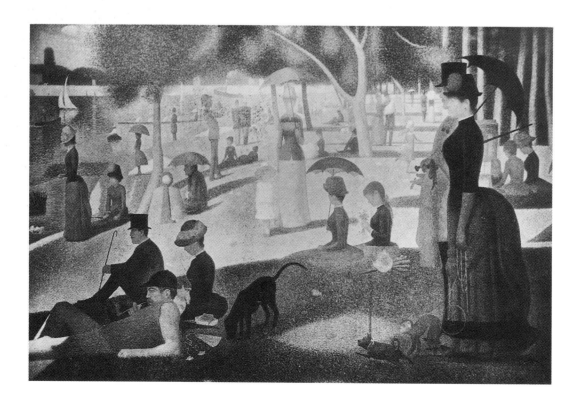

1892. Canvas, 89.5 x 116.5 cm. Metropolitan Museum of Art (Wrightsman collection), New York

On 23 January 1892 the dealer Durand-Ruel opened a large retrospective exhibition of Pissarro's work. It proved to be quite a grand affair. Seventy works were chosen and Lucien returned from London to assist with the arrangements. Georges Lecomte, Pissarro's great friend and later his biographer, was asked to write the introduction to the catalogue. Pissarro was nervous before the opening. He wrote to Lucien: 'Let's hope that something will come of this and that we won't be disappointed this time.' His doubts, however, were ill-founded and the exhibition was a great success; Pissarro received flattering reviews and high prices for his pictures. It is generally accepted that, after his years of dedication and hard work, this exhibition marked a turning point in his career.

After the show, his eyes began to cause him trouble. He had undergone an operation the year before to alleviate an infected tearduct, but the problem seemed to recur. The pain was exacerbated by wind and Pissarro was therefore obliged to return to work in his studio. Although he preferred to paint in the open air, he did appreciate the advantages of working in the studio – it was peaceful, gave him the opportunity to experiment with different methods and enabled him to rework the paintings that he had started outside.

It was perhaps these conditions that encouraged him to concentrate on the two figures rather than the landscape in this painting. Unlike the small figures in *The Apple Pickers* (Plate 31) Pissarro has brought the two girls right to the surface of the painting. Despite their closeness, he has chosen not to depict their characters or personalities. His interest lies rather in the design the figures make on the surface of the picture – the solidity of their forms compared to the delicate landscape behind. He has also studied the contrasts between the two figures. One stands while the other is seated, and one has her head covered while the head of the other is bare.

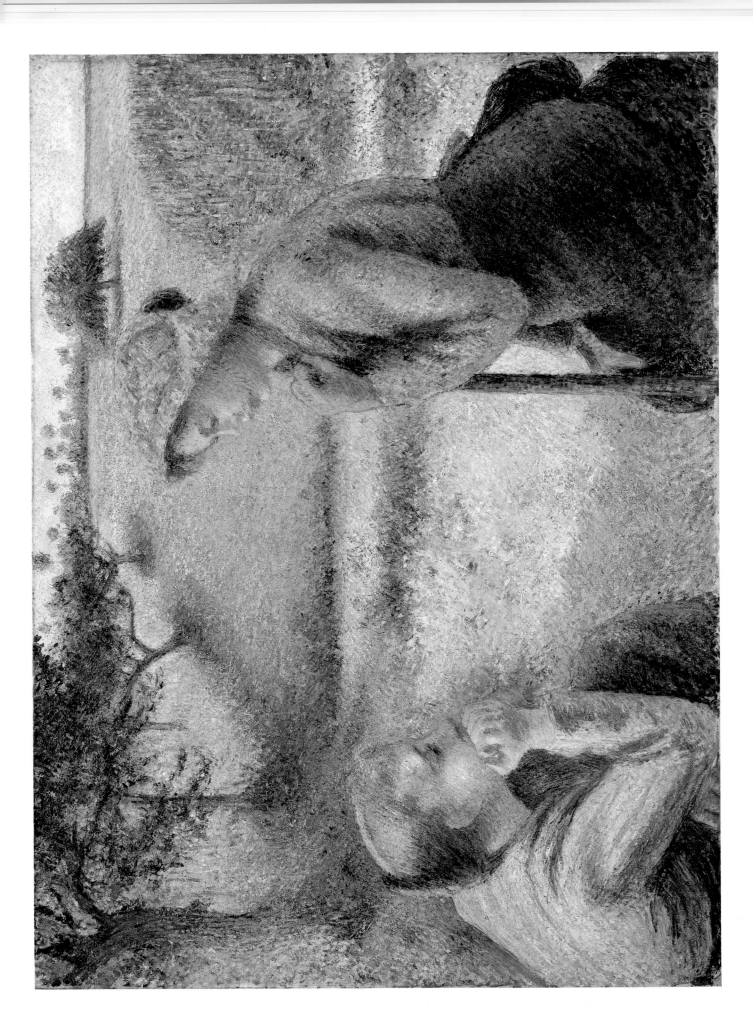

1895. Canvas, 73 x 92 cm. Sara Lee Corporation, Chicago

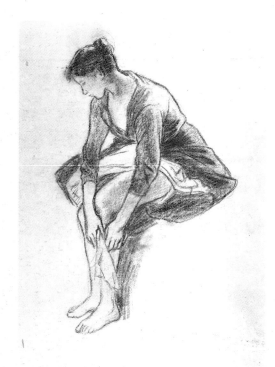

Fig. 32
Study of a Young
Woman bathing
her Legs

c.1895. Coloured chalks
and pastel on paper,
53.1 x 39.1 cm.
Ashmolean Museum,
Oxford

In 1894 Pissarro concentrated on two interrelated themes that were relatively new to him – the bather and the nude. Although these two subjects had been traditionally treated in the eighteenth century, the Impressionists had generally chosen to ignore them. In April 1894 Pissarro wrote to Lucien: 'The weather is very uncertain for the unhappy art of painting; I am content to triturate indoors. I have done a whole series of printed drawings in a romantic style which seemed to me to have a rather amusing side: *Baigneuses*, plenty of them, in all sorts of poses, in all sorts of paradises. Interiors, too, Peasant Women at their toilette, etc. Such are the motifs I work on when I can't go outdoors.'

Pissarro developed the compositions treated in these prints into full scale paintings. *Young Woman bathing her Feet* came about in such a way. Pissarro executed a preparatory drawing of the woman seated on the bank, which is now in the Ashmolean Museum (Fig. 32), and later started on the oil painting. He wrote to Lucien: 'As soon as I have something I will send it on to you. I have something which I think will be satisfactory, a *Little Peasant Girl Soaking Her Feet*, but it will have to lie around for the present; although it is unfinished, it lacks – well, something! I do think I will get it right, I feel that I will.'

Pissarro developed this theme further by painting another canvas of a woman in almost exactly the same position, but this time nude.

1895, Canvas, 65.2 x 53.8 cm. Art Institute of Chicago (Leigh B. Block collection)

Pissarro felt lonely at Eragny. Maximilien Luce and his wife came to stay for the summer, and by the time they left Pissarro felt slightly more inspired. On 11 October he wrote to Lucien: 'I am working steadily at my Figure paintings and am very fearful that I will not be able to finish them to my satisfaction'.

This period of equilibrium did not last long. Nine days later he wrote: 'I really want to go to Paris to see what is happening there. Despite a great sweep of work, I am very bored in Eragny ... Is it anxiety about money, the fact that the coming winter already makes itself felt, weariness with the same old motifs, or may be lack of data for the figure paintings I am doing in the studio? It is partly due to all these things, but what hurts me most is seeing the whole family breaking up, little by little. Cocotte is gone, soon it will be Rodo! Can you see us two old people, alone in this great house all winter?'

Young Girl mending her Stockings was painted during this period of distraction. Less interested in the strong compositional motifs, Pissarro has experimented with colour and design. The shape of the girl's lap is very similar to that of the cloth-covered table behind her, and Pissarro has chosen to contrast the two different kinds of striped material by painting one predominantly blue with a white stripe, the other predominantly white with a blue stripe.

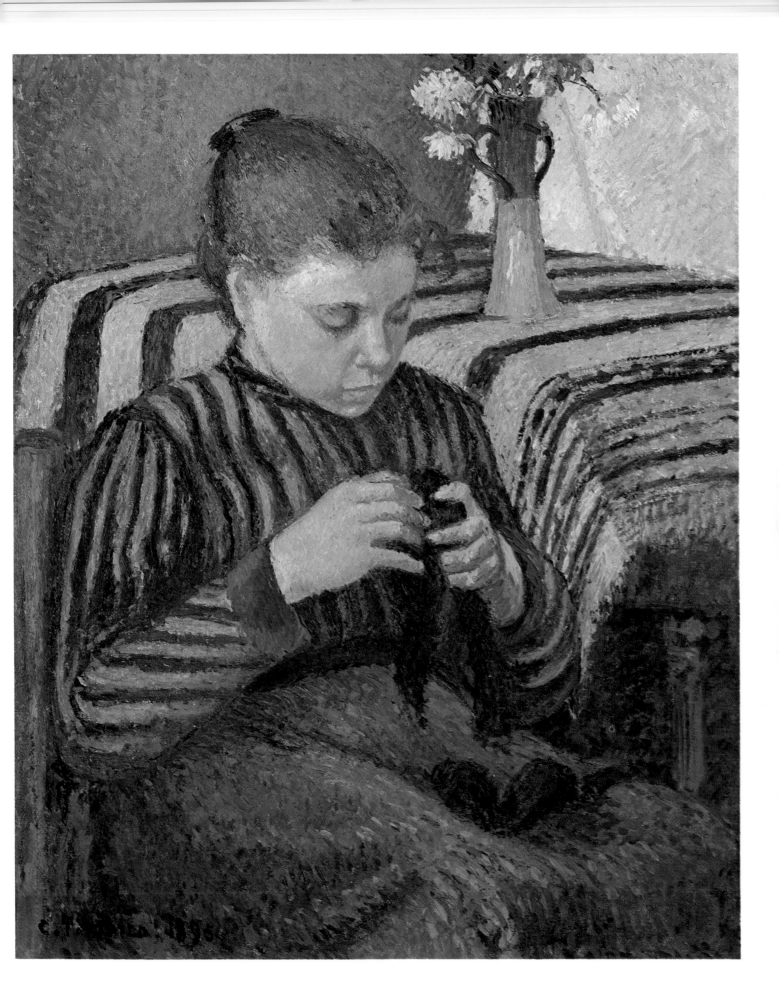

35 The Young Maid

1896. Canvas, 61 x 49.9 cm. David Bensusan Butt, London

The year 1896 was dominated by Pissarro's paintings of the port of Rouen. Within his hectic timetable he was able to return to the domestic environment of Eragny. Pissarro often studied the effects of littering an empty landscape with people, but here he appears to have done the opposite. Compared to *The Little Country Maid* (Plate 27), painted eight years earlier, *The Young Maid* is devoid of any objects; it has been depopulated. There is no table, no child, no paintings, no cups and saucers and only one, red, upholstered chair just visible on the righthand side. Rather than study the interaction of humans and objects, as he did in Plate 27, Pissarro has concentrated on the illusion of space and three-dimensionality. He has created the illusion of depth more thoroughly in this painting than in any other in this book.

The space is so real that it is possible to walk through the house step by step. We know that the first room, the one in which we presume Pissarro is standing, extends behind and on either side of us. Standing before us is the young maid, holding a glass carafe in her right hand and the door, which she has just opened, in her left. Behind the girl is another room, smaller this time, perhaps a corridor, with dark walls. On the far wall of this small room is an open doorway leading into a third space. Although only a small section is visible it appears to be a spacious room with large windows. In turn, the transparent glass invites us into a further dimension as we look through into the garden which is suggested by the bright green colour of the foliage. Having 'walked' this far, our eye is caught by the light falling through the window drawing us gradually back into the room in which we started. This circular journey is also helped by the touches of green receding from the garden to the door jamb in the centre, and finally the touch of colour on the carafe.

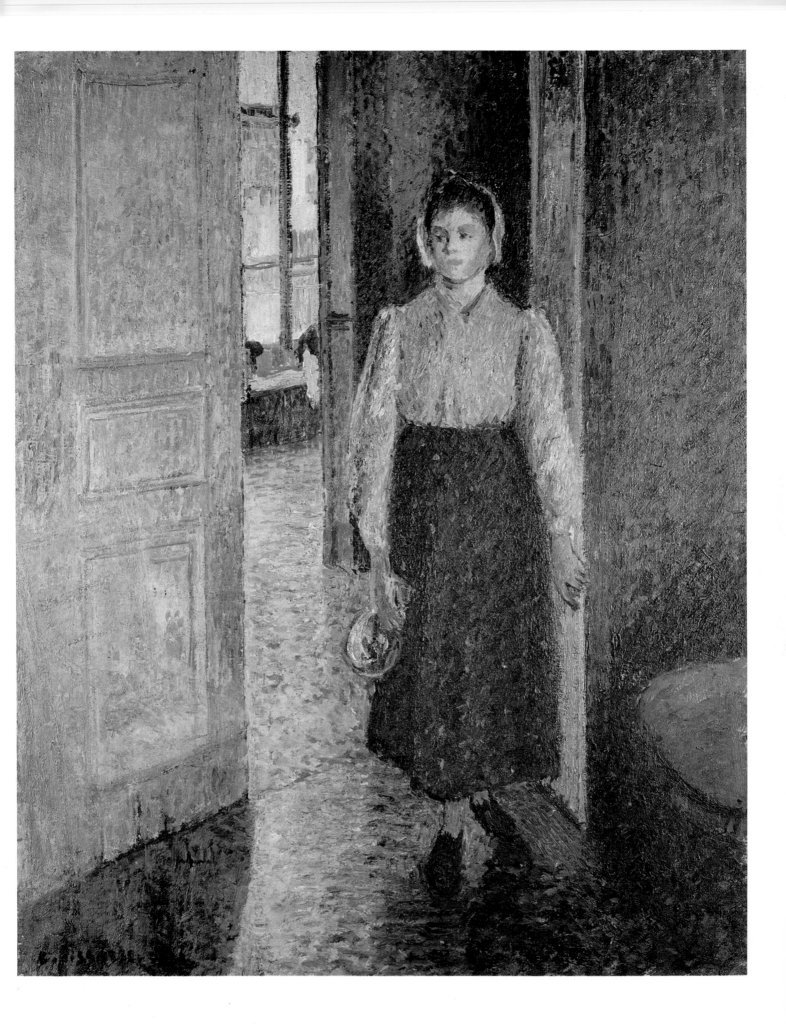

The Great Bridge, Rouen

1896. Canvas, 74.3 x 92 cm. Carnegie Institute, Pittsburgh Museum of Art

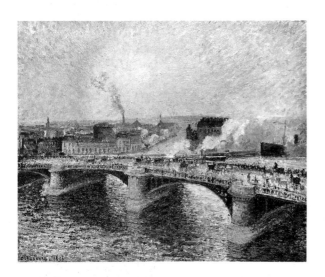

Fig. 33
The Boieldieu
Bridge, Rouen,
Sunset

1896. Canvas, 73 x 92 cm.
City of Birmingham Art
Gallery

In 1896 Pissarro painted an important series of paintings of the port and bridges crossing the Seine at Rouen. Impressed by Monet's series paintings of the 1890s, he chose to depict almost identical views subject to different weather conditions.

Pissarro made two visits to Rouen during that year. The first, which was partially incited by boredom, took place towards the end of January. Lucien, his wife Esther and baby Orovida, had recently returned to London after a prolonged stay at Eragny and Pissarro felt distracted. He left for Rouen on 20 January, and on his arrival wrote to Lucien from the Hôtel de Paris: 'I arrived today from Paris. I am going to get down to work as soon as I get my materials, which are being sent from Eragny. I have a splendid view over the harbour.' His temporary depression had obiously lifted and he felt inspired and eager to work. *The Boieldieu Bridge, Rouen, Sunset* (Fig. 33) was painted from his window at the Hôtel de Paris.

The Great Bridge, Rouen was painted during his second visit. He arrived on 2 September and took a room at the Hôtel d'Angleterre which, like the previous hotel, looked out over the port but from a different angle. Pissarro has depicted a bustling port scene. There are seamen in the foreground working on boats, people, horses and carriages crossing the bridge and chimneys fervently churning out smoke from the apparently productive factories. He obviously found the change of scene in Rouen very inspiring. During his first trip in 1896 he painted about twelve paintings and by the end of the second trip he had fininshed a grand total of twenty-eight.

His stay came to an end as his eyes were again giving him trouble. On 11 November he wrote to Lucien: 'I am leaving tomorow by express for Paris. I must go and have my eye cauterized by Parenteau, it is again inflamed. I just dispatched to Eragny fifteen pictures, in which I tried to represent the movement, the life, the atmosphere of the harbour, thronged with smoking ships, bridges, chimneys, sections of the city in fog and mist, under the setting sun etc... . I think that what I have done is bolder than what I did last year.'

37 Boulevard des Italiens, Paris, Morning, Sunlight

1897. Canvas, 73.2 x 92.1 cm. National Gallery of Art (Chester Dale Collection), Washington DC

Pissarro spent December 1896 in Eragny, and at the beginning of the new year returned to Paris where he began a series of paintings devoted to the Grands Boulevards. In February he wrote to Lucien: 'I am returning to Paris again on the tenth, to do a series of the boulevard des Italiens. Last time I did several small canvases ... of the rue Saint-Lazare, effects of rain, snow etc., with which Durand was very pleased. A series of painting of the boulevards seems to him a good idea, and it will be interesting to ovecome the difficulties. I engaged a large room at the Grand Hôtel de Russie, 1 rue Drouot, from which I can see the whole sweep of boulevards almost as far as the Port Saint-Denis, anyway as far as the boulevard Bonne Nouvelle.'

We have seen that Pissarro was already studying atmospheric effects in the early 1870s (see Plate 8) and in Rouen (see Plate 36). Here, as in Monet's series paintings of the late 1880s and 1890s, Pissarro treats the same view or landscape but at different times of the day and under different weather conditions. At times, indeed, the actual weather condition becomes more important that the scene itself.

For several years Pissarro had been studying the way in which a scene could be totally transformed by introducing figures going about their everyday activities. Here we see a view of the Boulevard des Italiens looking down from his window at the Grand Hôtel de Russie. We are faced with a typical view of Parisian society: people walking, window shopping, riding on or queuing for horse-driven omnibuses. The static elements of the landscape are transformed by the bustling activity of the crowd.

La Place du Théâtre Français, Paris, Rain

1898. Canvas, 73.6 x 91.4 cm. Institute of Fine Arts, Minneapolis

Towards the end of 1897 Pissarro rented a room at the Grand Hôtel du Louvre on the Place du Palais Royal. His window overlooked the Rue Saint-Honoré, the Avenue de l'Opéra and the Place du Théâtre Français. Pissarro wrote to Lucien about this view: 'It is very beautiful to paint! Perhaps it is not aesthetic, but I am delighted to be able to paint these Paris streets that people have come to call ugly, but which are so silvery, luminous and vital. They are so different from the boulevards. This is completely modern.'

He began this series at the very end of 1887 and continued into the spring of the following year. Here we are looking down onto the Place du Théâtre Français. The scene is similar to that in *Boulevard des Italiens* (Plate 37) – a large street littered with figures, this time standing under umbrellas to protect themselves from the rain. The effect, however, is different. Pissarro has concentrated on the illusion of static space rather than the depiction of a bustling street. The figures and carriages are not placed randomly throughout but are carefully positioned to form two neat rows as they approach the Opéra in the upper lefthand corner. The buildings on the right have also been doctored: the lines formed by the cornicing and architectural detail have been carefully matched so that they seem automatically to lead from one building to the next. The balustrade of the first building neatly merges with the upper story windows of the building behind. As in his ealier pictures, Pissarro has again used regimented, horizontal and vertical lines to exaggerate an effect of static space.

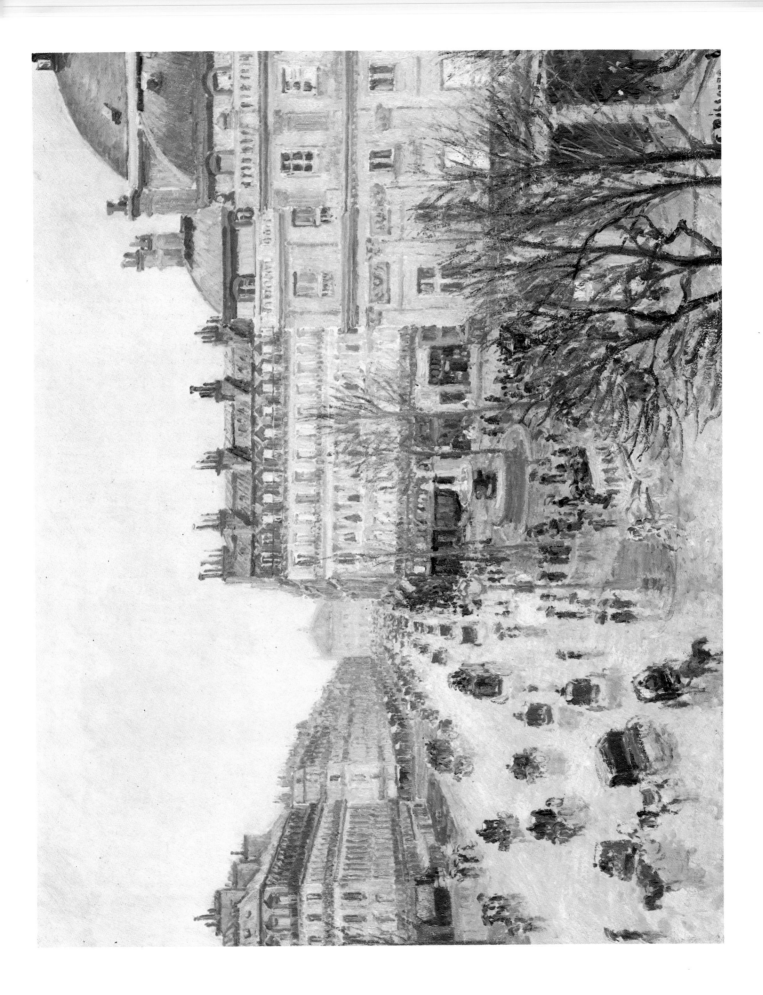

1899. Canvas, 65 x 92 cm. Ashmolean Museum (Pissarro Gift), Oxford

In January 1899, Pissarro and Julie took an apartment in Paris at 304 rue de Rivoli. It had a superb view of the Tuileries Gardens, with the Louvre on the left and the Invalides on the right. For the first few months the weather was diabolical, and Pissarro painted many canvases of the gardens, giving eleven to Durand Ruel and keeping three for himself.

He wrote to Lucien: 'We have at last moved in and unpacked and I am hard at work. I have the Jardin des Tuileries facing me and to the left the Place du Carrousel and the Louvre, it is very beautiful. Until now I have only been able to paint the effects of grey and rainy days for since our arrival we have had miserable weather with winds that could unhorn bulls. They sweep across this great open space and make a deafening racket.'

Sisley was taken seriously ill in January and died at the end of the month. He had been a great friend and supporter to Pissarro, who felt his loss deeply. He wrote to Lucien again on 12 April: 'I have done much work on my Tuileries series. I shall have an important canvas, *The Garden of the Tuileries on a Winter Afternoon*, for an auction, the proceeds of which are to go to Sisley's children ... There will also be a Monet and an important Renoir. It is expected to be an exceptional sale.'

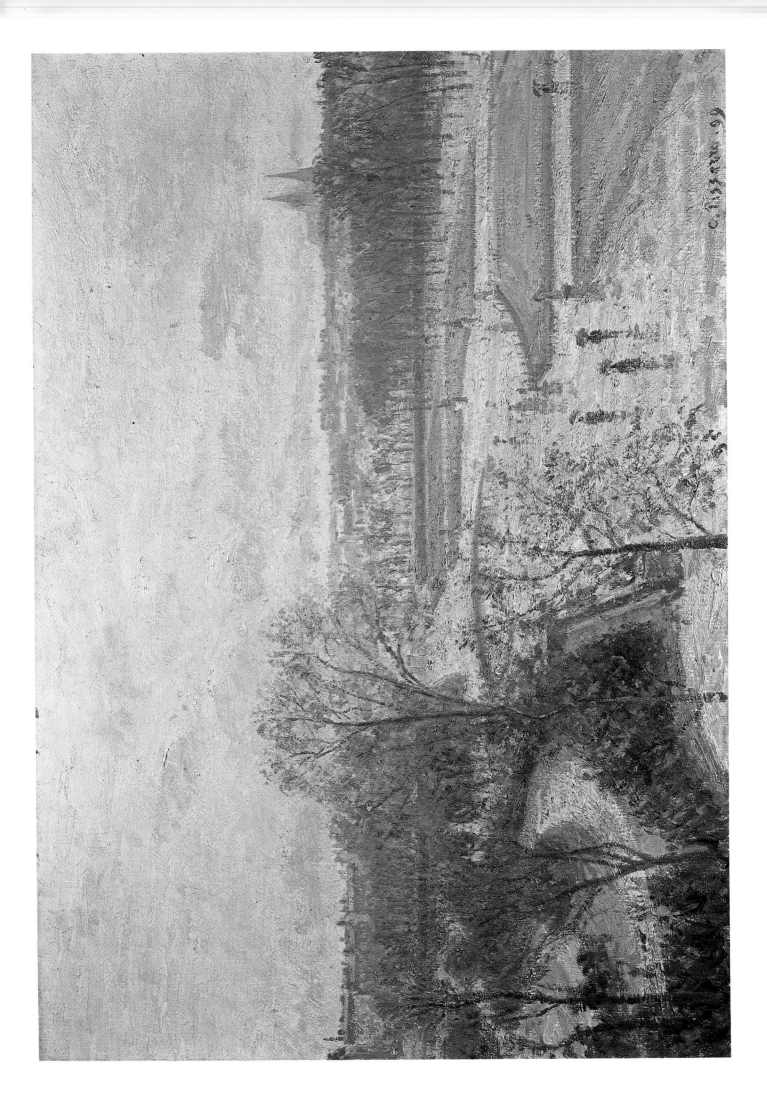

40 The Old Market and the Rue de l'Epicerie, Rouen, Morning, Grey Weather

1898. Canvas, 81 x 65.1 cm. Metropolitan Museum of Art (Mr. and Mrs Richard J. Bernhard Fund), New York

Pissarro returned to Rouen towards the end of the summer of 1898 and stayed there until October. He has said to Lucien that he was determined to find new motifs. He wrote: 'Since I can't always work at Eragny, I am forced to go to places where I can find attractive and interesting motifs, and this is expensive, very expensive. Fortunately I am still able to work. Yesterday I discovered an excellent place, where I hope to paint the rue de l'Epicerie and even the market, a really interesting one, which is held there every Friday.'

Pissarro embarked on a series of three pictures of the rue de l'Epicerie, painted from approximately the same position. Plate 40 is the only canvas to show the market taking place: there are trestle tables displaying wares, awnings and umbrellas to protect the goods from the sun and a swarm of people walking, looking and talking. The effect of movement is enhanced by the patchwork of shapes and colours made up by the walls, windows and roofs of the buildings leading up to the cathedral.

The Rue de l'Epicerie, Rouen, Morning, Grey Weather (Fig. 34) shows a slightly different view of the same subject. Pissarro has moved slightly to the right, so that we can now see further up the rue de l'Epicerie which leads to the cathedral.

Fig. 34
The Rue de l'Epicerie, Rouen, Morning, Grey Weather

1898. Canvas, 81 x 65 cm.
Private collection

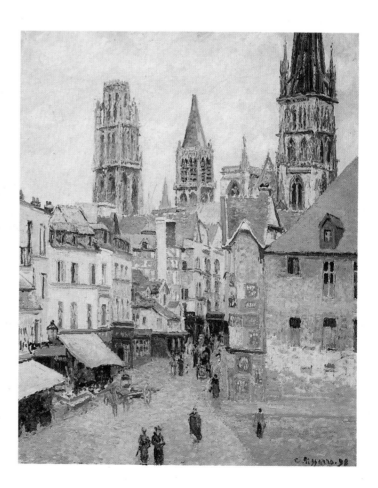

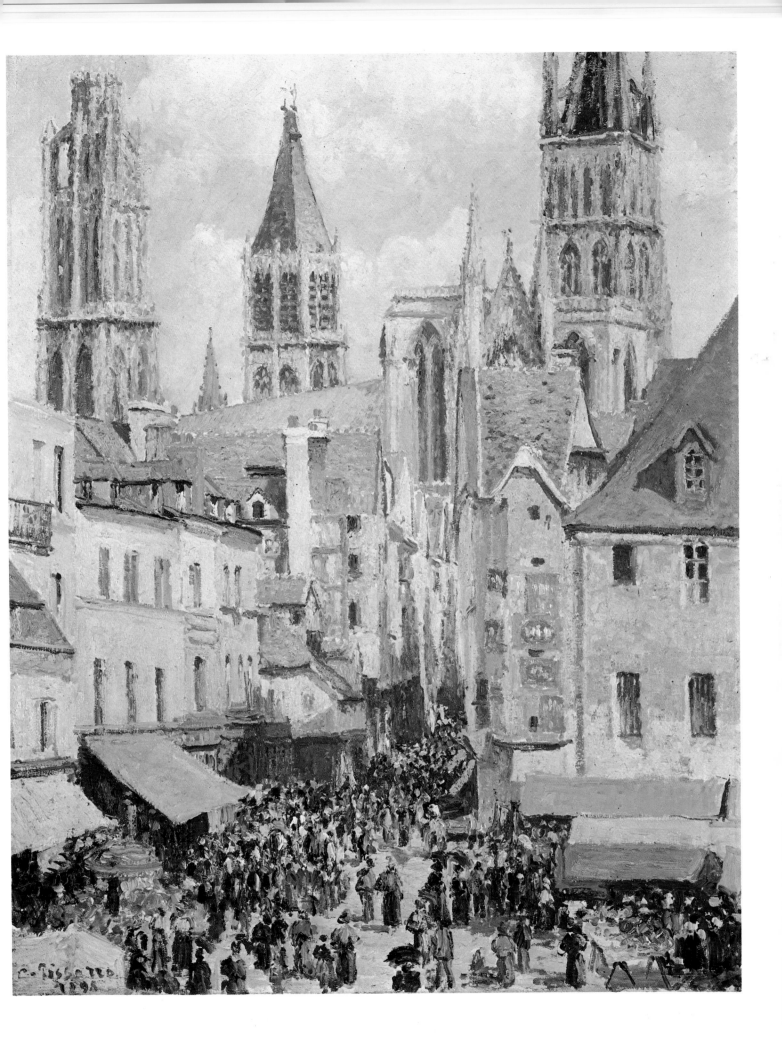

The Church of Saint-Jacques, Dieppe

1901. Canvas, 54.5 x 65.5 cm. Musée d'Orsay, Paris

Pissarro spent the summers of 1901 and 1902 in the seaside town of Dieppe. On 19 July 1901 he wrote to Lucien: 'I am leaving tomorrow for Dieppe. I am going to stay at the Hôtel du Commerce, Place Duquesne. I shall have a window that overlooks the church of Saint-Jacques, rather picturesque towers and houses.' The view from his window was important: since his eyes were still causing him trouble he needed to paint from a position where his eyes would be protected from the wind.

During his first trip in 1901 he painted a total of eight pictures, of which seven depicted the church. Four of these seven focus on the market stalls of the annual summer fair which took place in the square in front of it. The remaining three concentrate on the gothic edifice itself as the dominant image. In Plate 41 Pissarro has contrasted the solidity of the architectural edifice with the small and comparatively delicate buildings on the right as they stand on the curve of the rue Saint-Jacques.

In *Portal of the Church of Saint-Jacques* (Fig. 35), despite the three stalls and trickle of figures towards the lower righthand corner, Pissarro has surrendered himself to the architectural detail. The slightly stunted building from Plate 41 has now totally taken over the canvas.

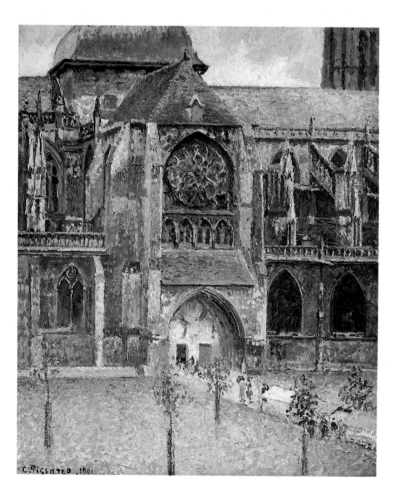

Fig. 35
Portal of the Church of Saint-Jacques, Dieppe

1901. Canvas,
78.5 x 65 cm.
Private collection

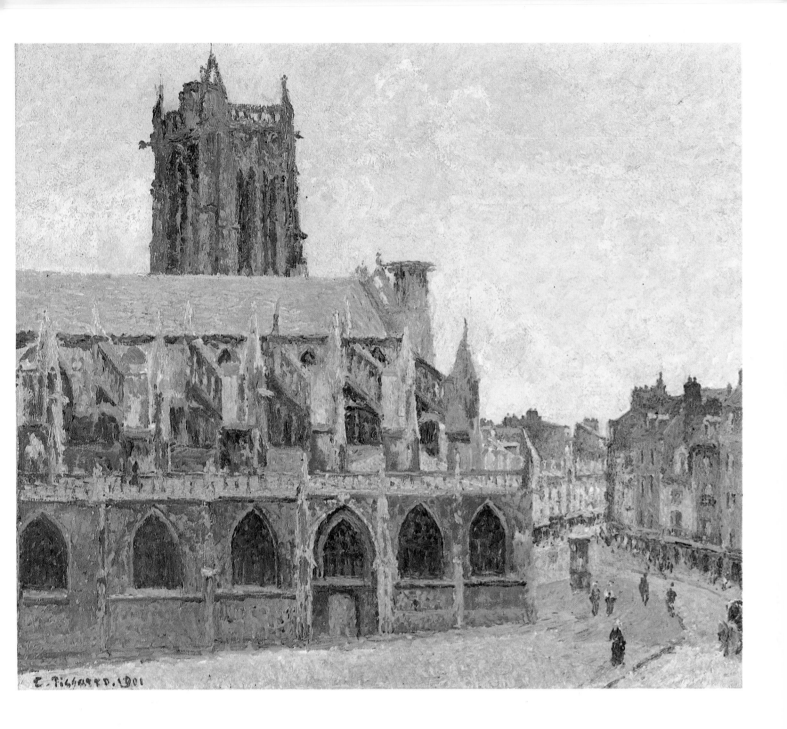

1901. Canvas, 51.5 x 64.7 cm. National Gallery of Canada, Ottawa

As Pissarro grew older he became increasingly restless. In the last few years of his life he was continually travelling to find new subjects and motifs. In 1901 he wrote letters to Lucien from Paris, Caen, Dieppe and Eragny. He was forever on the move and visited some of these towns more than twice during the same year. The paintings resulting from these trips seem to be primarily urban or port scenes; apart, of course, from the works executed in Eragny.

Pissarro started concentrating on the everyday tasks of the rural French community during his stay at Piette's farm at Monfoucault in 1875 (see Plate 19). However, whereas in the mid 1870s his peasants and cowgirls were generally merged into their natural surroundings, here they are placed well into the foreground, so that the picture is considered a composition of figures rather than a landscape. The five women in the foreground are very carefully positioned. The three standing figures are placed at intervals with the bending figures between them, creating a rhythmical continuity across the surface of the painting. Our eye rests first on the woman with her back to us on the righthand side. Her pointed elbow starts a line which draws us through the composition along the arms and shoulders of the other haymakers, until we reach the upright pole and the configuration of hands on the left.

This serene and undulating composition no longer demonstrates the sociological commentaries which were found in Pissarro's earlier works. Rather it is an idealized view of a harmonious rural world.

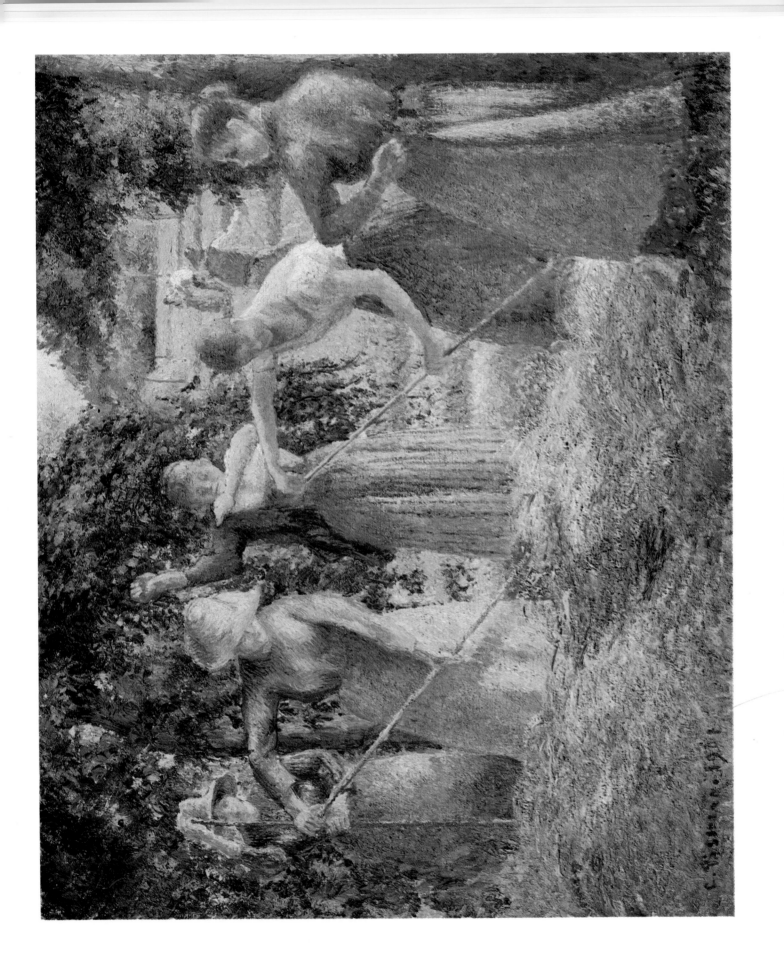

Sunset at Eragny

1902. Canvas, 73 x 92 cm. Ashmolean Museum (Pissarro Gift), Oxford

Following his second visit to Dieppe, in the autumn of 1902 Pissarro returned to Eragny where he painted a number of canvases depicting the meadow near his home. After the hectic, bustling market and port scenes, Pissarro has truly returned to nature. He painted a series of similar works at this time which, like *Sunset at Eragny*, are devoid of any human interest. He has chosen a quiet corner of the meadow, with no figures and no buildings visible even in the distance.

These works, which were painted from the studio window, were apparently heavily worked over a long period. The technique shows similarities with Pissarro's paintings of 1877. Although some of the brushstrokes are longer and more fluid, they suggest that his brush was heavily laden with pure pigment He has used a full spectrum of colours ranging from blue, green, yellow and brown to traces of purple and red. On close inspection it is possible to see how he reworked a number of the trees in the foreground.

The death of Emile Zola on 29 September 1902 deeply distressed Pissarro. He wrote to Lucien: 'You have heard that Zola is dead. It is a terrible loss to France! ... I sent my condolences to his widow, but I do not believe, considering my age, that I can attend the funeral. I would not dare follow the procession.' This event seems to have reminded Pissarro of his own age, and perhaps the tinge of melancholy that we detect in *Sunset at Eragny* reflects this consideration of mortality.

44 Dieppe, Duquesne Basin, Low Tide, Sun, Morning

1902. Canvas, 54.5 x 65 cm. Musée d'Orsay, Paris

Pissarro returned to Dieppe in the summer of 1902. He wrote to Lucien: 'Well, here I am in Dieppe at the Hôtel du Commerce. I have rented a room on the second floor under the arcades of the fishmarket. This is my studio. I have a first rate motif, indeed I have several ... There aren't many people here but the place will fill up later. The beautiful weather is attracting visitors, the English are the first to come as tourists and excursionists. However, the coronation, to which I am completely indifferent may keep them at home.' One of the Englishmen that Pissarro met in Dieppe was the painter Walter Sickert, who had lived in a villa just outside the town since 1899.

In August 1902 Pissarro again wrote to Lucien: 'My motifs are very beautiful: the fishmarket, the inner harbour, the Duquesne basin, in the rain, in the sun, in the smoke etc., etc ...'.

Pissarro painted seventeen oils on these themes. This painting depicts a view of the inner harbour. He has chosen to paint early in the morning without the hustle and bustle of fishermen and passers-by. A few people sit or stand looking down at the water's edge, and an unharnessed cart lies on the quay. Through the stillness we are able to feel the warmth of the morning sun.

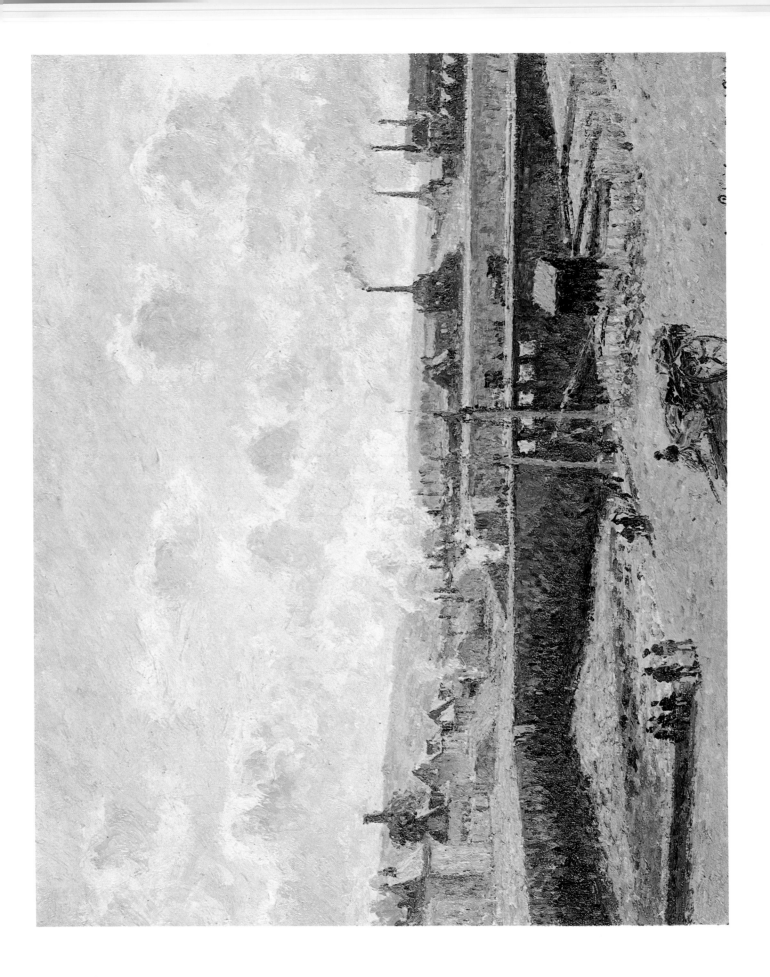

45

The Pilot's Jetty, Le Havre, Morning, Grey Weather, Misty

1903. Canvas, 65 x 81.3 cm. Tate Gallery, London

Even in the last months of his life Pissarro was looking for new subjects and motifs. In 1903 he travelled to Le Havre, where he made a series of eighteen paintings of the jetty, dockside and inner harbour. Pissarro tried, as he had in Rouen, to find accommodation with a view from the window. He and Julie took a room at the Hôtel Continental, from where they had a panoramic view over his subject.

Pissarro wrote to Lucien: 'Unfortunately everything works out at cross purposes this year. Since things were so bad I was compelled to do a series which I thought would please my collectors: *The Jetty at Le Havre*, of which the people are proud; and really it has character.'

Pissarro has painted the jetty on a grey, misty morning. The clouds scud across the sky and a crowd of people stand by the water's edge watching the boats as they sail out of the harbour. Just before his departure in September he again wrote to Lucien: 'I intend to leave towards the 26th of this month. I sold two pictures to the museum and two to collectors, but I am hardly besieged by demands! I see that we are far from being understood – quite far – even by our friends.'

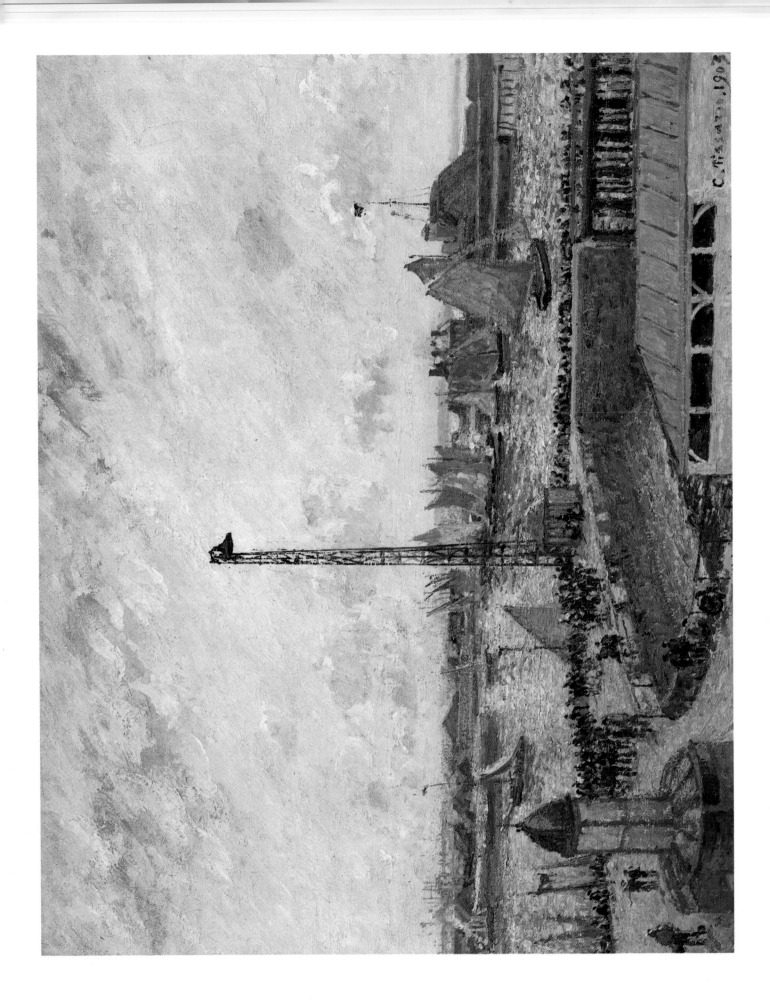

The Pont Royal and the Pavillon de Flore, Paris

1903. Canvas, 54 x 65 cm. Musée du Petit Palais, Paris

In March 1903 Pissarro moved from his apartment at 28 Place Dauphine and rented a room at the Hôtel du Quai Voltaire. At the end of the month he wrote to Lucien: 'I am doing at present a series of canvases from the Hôtel du Quai Voltaire: the Pont Royal and the Pont du Carrousel, and also the sweep of the Quai Malaquais with the Institut de France in the background and, to the left, the banks of the Seine; superb motifs of light'.

It is difficult to believe that this work was painted only a few months before Pissarro's death. He has successfully caught the fresh and slightly sharp atmosphere of a day in early spring. There is absolutely no evidence of the hand of a man declining in years or health. His palette is still fresh and his touch is confident and effective. He has cleverly contrasted the weight and three-dimensionality of the Pont Royal with the flowing expanse of the Seine as it runs beneath.

The Pont Royal and the Pavillon de Flore is one of twelve canvases depicting the same view, painted during the months of March, April, May and June. Pissarro has chosen to concentrate on the effect of light on his subject at different times of the day and as spring develops into summer.

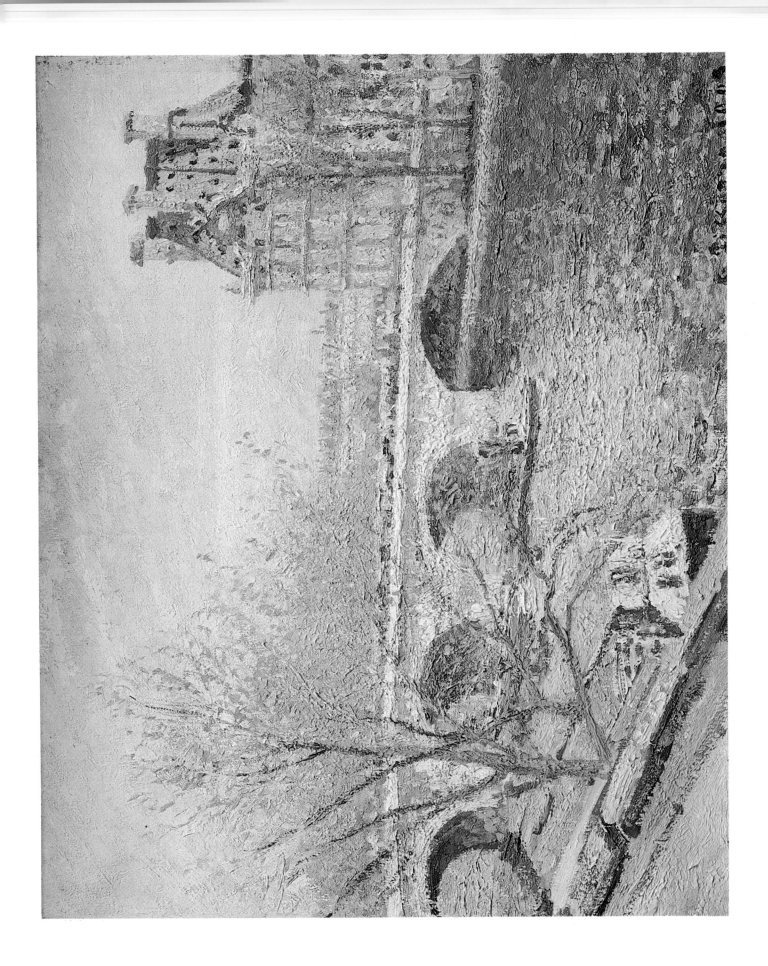

The Seine and the Louvre, Paris

1903. Canvas, 46 x 55 cm. Musée d'Orsay, Paris

Pissarro moved to an apartment on the Ile de la Cité at the beginning of 1900. He wrote to Lucien on 16 March: 'I found an apartment on the Pont Neuf [28 Place Dauphine]. It has a very fine view. I am going to move in July. This should not influence your trip here, I am simply afraid of failing once again to avail myself of a picturesque part of Paris.' The view from his window gave him an extensive range of buildings, parks and statues to reproduce in paint.

Between March 1900 and 1903 he executed three sets of series of these varied views, which included the Pont Neuf, the Place du Vert-Galant with the statue of Henri IV, the Louvre and the Pont des Arts, visible in the middle distance in this picture.

The Seine and the Louvre, Paris is one of the eight works belonging to the final series of 1903. Pissarro appears to have worked quickly to capture the effect of the last light of the day as it disappears behind the buildings. His brushstrokes are large, expressive and sometimes purely suggestive. His main aim is to capture the atmosphere of the time of day. His interest, therefore, in depicting the tree on the left for example, is minimal. He has concentrated mainly on the colour and warmth of the open sky, and with a few brushstrokes has merely suggested the presence of the couple on the Place du Vert-Galant in the foreground.

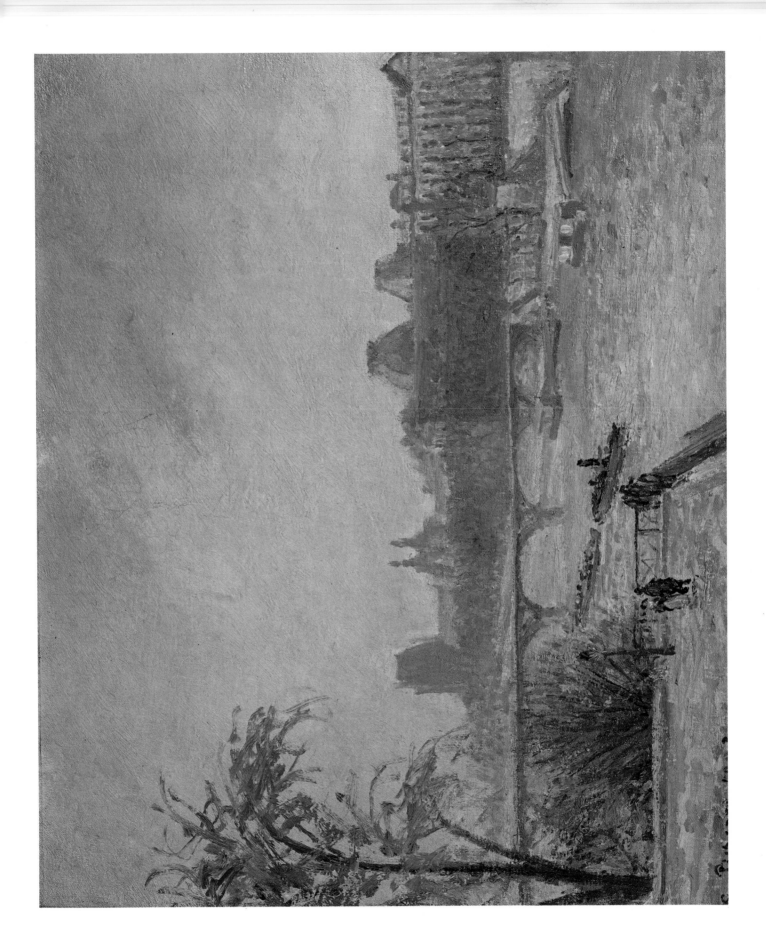

Self-Portrait.

1903. Canvas, 41 x 33.3 cm. Tate Gallery (Pissarro Gift), London

Pissarro was seventy-two when he painted his forth and final self-portrait. He had returned to Paris in November 1902, having spent the summer in Dieppe. Here we see him during the first few months of 1903 in his studio at 28 Place Dauphine. Despite his age we are faced with a man who is still acutely aware of everything around him, as he looks intently out at us from behind his half-moon glasses. His dominating form, dressed all in black with his full grey beard, appears to be so physically close to the picture surface that it seems to bridge the gap between our space and the room behind him.

Forever fascinated by form and structure, Pissarro has carefully placed his head and hat between the solid, vertical bands of wall, window and outside view which are counteracted by the strong horizontal line of the brim of his hat. The buildings seen through the open window have been identified as those once on the site of the Samaritaine on the north side of the Pont Neuf. Here the buildings are seen in reverse, as Pissarro used a mirror to paint this self-portrait. A few months later, in September of the same year, Pissarro collapsed on the steps of his home and, after a painful illness, died on 13 November 1903 at the age of seventy-three.

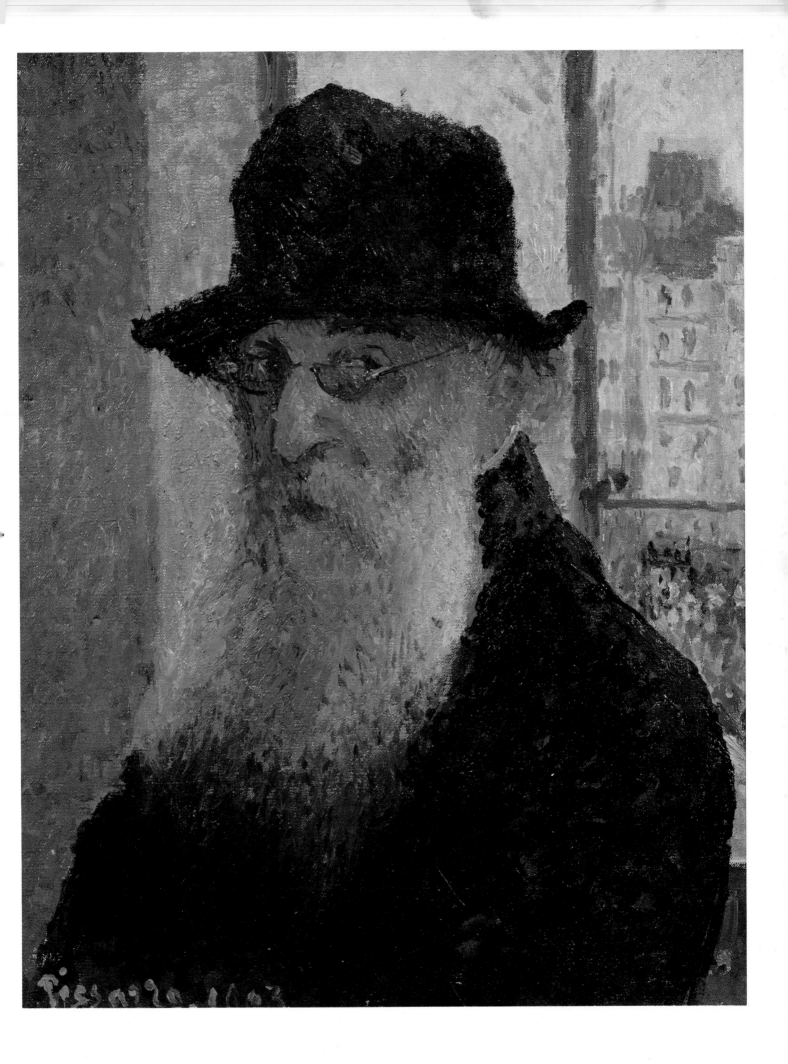

PHAIDON COLOUR LIBRARY

Titles in the series

BRUEGEL
Keith Roberts

CEZANNE
Catherine Dean

CONSTABLE
John Sunderland

DEGAS
Keith Roberts

DUTCH PAINTING
Christopher Brown

ERNST
Ian Turpin

FRA ANGELICO
Christopher Lloyd

GAUGUIN
Alan Bowness

HOLBEIN
Helen Langdon

ITALIAN RENAISSANCE PAINTING
Sara Elliott

JAPANESE COLOUR PRINTS
J. Hillier

KLEE
Douglas Hall

MAGRITTE
Richard Calvocoressi

MANET
John Richardson

MATISSE
Nicholas Watkins

MODIGLIANI
Douglas Hall

MONET
John House

MUNCH
John Boulton Smith

PICASSO
Roland Penrose

PISSARRO
Christopher Lloyd

THE PRE-RAPHAELITES
Andrea Rose

REMBRANDT
Michael Kitson

RENOIR
William Gaunt

SURREALIST PAINTING
Simon Wilson

TOULOUSE-LAUTREC
Edward Lucie-Smith

TURNER
William Gaunt

VAN GOGH
Wilhelm Uhde